LEARN TO
PRINT
STEP·BY·STEP

LEARN TO
PRINT
STEP·BY·STEP

Bruce Robertson
and
David Gormley

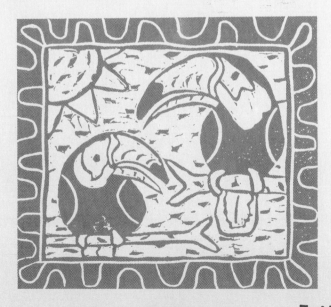

Macdonald Orbis

A MACDONALD ORBIS BOOK

© Diagram Visual Information Ltd 1987

First published in Great Britain in 1987
by Macdonald & Co (Publishers) Ltd
London & Sydney

A member of BPCC plc

British Library Cataloguing in Publication Data
Robertson, Bruce
 Learn to print step-by-step.
 1. Prints – Technique
 I. Title II. Gormley, David
 760'.28 NE850

ISBN 0-356-12457-6

The Diagram Group

Design director	Philip Patenall
Editor	Reet Nelis
Art staff	Joe Bonello, Brian Hewson, Richard Hummerstone, Lee Lawrence, Johanna Lidman, Marlene Williamson
Illustrator	Graham Rosewarne
Technical consultant	Walter Hudspith A.R.C.A.

Acknowledgements/
Picture credits J Anderson 52; F Andri 153; M Barron 60, 88, 89, 108;
Beggarstaff Bros. 154; W Blake 152; L Boyd 58;
J Chieze 33; P Clarke 90, 110, 111; J de Man 87;
P du Pont 87; A Dürer (British Museum) 91, (Albertina
Museum, Vienna) 97; R Frances 123; J Fraser 96;
P Gauguin 152; D Gormley 9, 10, 26, 27, 29, 36, 41, 42,
43, 66, 67, 69, 74, 76, 77, 84, 85, 100, 102, 112, 113, 122,
126; S W Hayter 115; R Hipkins 9; Hokusai 13, 80;
R Hummerstone 145; K Jupp 91; G Kneller 85, 114;
E Nakano 139; V Ortiz 64, 65, 67, 72, 73; J Ostrowski 77;
K Parker 68; S Prout 102; B Robertson 117; M Robertson
180; Rembrandt 84, 153; J Simpson 185; G L Thomson
(*Rubber Stamps*, Canongate) 33; F Vallottan 27;
M Williamson 41; M Wilson 105.

Filmset by Bournetype, Bournemouth
Printed and bound in Spain
Gráficas Reunidas, S. A., Madrid.

Macdonald & Co (Publishers) Ltd
Greater London House
Hampstead Road
London NW1 7QX

Foreword

We all need printed things, whether greeting cards, writing paper, school and club posters or magazines. Producing them yourself, either in part or completely, can be very satisfying, and you do not need years of training or extensive and expensive equipment.

Printing is only the reproduction of words or images you have created. The assembly of the artwork and some of the printing processes are not as difficult as you might imagine once you have been shown how and followed a few step-by-step instructions. Of course, your first efforts won't be up to the standard of the great master printers, but they will certainly be satisfying.

This book is an introduction to the practical aspects of producing your own artwork and prints. It is not concerned with high-technology mass-production printing, nor with the mystique of the craft printer. LEARN TO PRINT will show you how easy it is to master the basics. You can start off with easy projects – linocuts and woodcuts – and then go on to the more complex techniques of engraving, etching and even producing your own lithographic print.

You won't believe what exciting, satisfying, and even money-saving, results you will soon be producing.

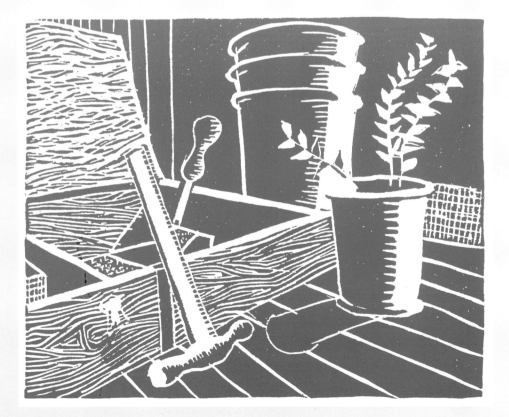

Contents

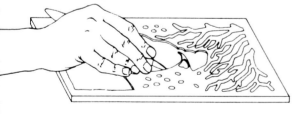

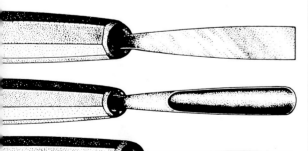

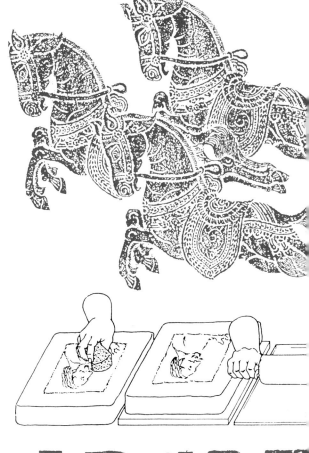

Part One

CHOOSING A METHOD

Methods of reproduction

There are four major methods of duplicating images by printing: (**1**) the relief process, where raised surfaces are inked and pressed onto paper; (**2**) the intaglio process, where incised (lowered surfaces) are inked and pressed onto paper; (**3**) the surface process, where flat areas are inked and pressed onto paper;

(**4**) the stencil process, where holes allow ink to pass through a surface onto paper. Each method offers unique qualities and different results. Before transforming your drawing to a reproduction method, first consider the available opportunities that each method offers.

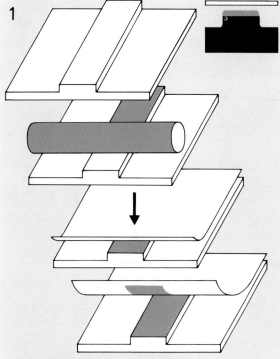

The relief process
The most common materials from which you can cut away areas, which will appear white when the raised inked surfaces will print black, are: linoleum (linocuts); wood (woodcuts, when using the side surface; wood engraving, when using the end surface); and metal (either by phototransfer of the image, which is then etched to produce a raised gradation of dots called a halftone, or by pressing the shapes into metal, the method originally used to produce type fonts).

The intaglio process
The most common material into which incised lines are cut is metal, usually copper, zinc or steel. The grooves may be scratched (drypoint), cut (engraving), or bitten into the surface with acid (etching). Tonal areas can be obtained by etching into porous granulated covering (aquatint) or engraving with multi-pointed tools (mezzotint). Commercial printing techniques transfer the image by photography, then the details are etched into the plate. This method (photogravure) is most often used for four-colour magazines.

Understanding prints

This book is printed by lithography, a surface printing method, so all the examples are transformed from original prints into the book's method of reproduction. This often results in a loss of the unique characteristics of a printing technique. Detail of an etching (*right*). The original would feel rough to the touch.

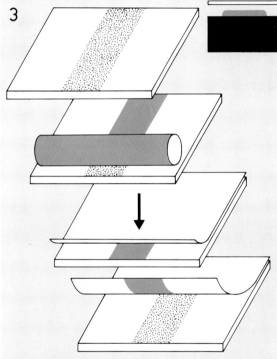

The surface process

This method, the planographic technique, uses the principle of water-resistant marks retaining printing ink. Originally developed from drawing onto smooth-surfaced stones (lithography), it is now used on prepared metal plates. Depending on the surface of the plate, and the tools used to produce the drawing, great detail of tone, texture and line can be achieved. This book is printed by this method and is closest to obtaining exact copies of the original work.

The stencil process

Images are cut into a strong, thin material and ink pushed through onto the paper, either by brushes, rollers or a squeegee (a rubber blade). Fine details are difficult to achieve. Rather than cut completely through a surface, the intended areas may be left clear on a stretched material, and the areas not being printed protected by a filler (silkscreen printing). This method usually requires you to simplify the design of your drawing.

Colour prints

There are numerous methods of obtaining colour effects on your print. Each method offers new dimensions in the drawing and exploring these effects can greatly improve your work. Because of the results of overprinting colours, each additional printing adds more colour values, as the overlap of transparent colours influences the colours and tones beneath.

Single colour effects
Try printing your design in a coloured ink (**1**), printing it on a coloured paper (**2**), or printing in a coloured ink on a coloured paper (**3**).

Overprinting (*below*)
You can explore the effects of overprinting by using one block, inked in different colours, and printed in a changed position. First, print a number of copies of your design (**1**), then clean the block and reprint over the original image in a different colour and a different position (**2**). You will enjoy the new colours (**3**) which are the result of the overprinting effects. This can only work if the colours are transparent and the ink film thin.

© DIAGRAM

Coloured blocks
Two methods of adding
colour are achieved on the
inking of a block. You can
ink two areas in different
colours, or you can ink a
block with a gradation of
colour. This method requires
skill in obtaining a series of
similar prints from hand-
produced gradated areas.

Added colour
The simplest way is to add
areas of colour by hand. It
requires strong paper as thin
paper will buckle when
water-based colours are
added. The colours must
also be transparent or they
will obscure some of the
printed details. (19th-
century French hand-
coloured woodcut, enlarged.)

Gradated colours
Lithography and gravure
offer opportunities to apply
gradations of colour. These,
when overprinted with other
colours, create a wide range
of tonal and chromatic
effects. (19th-century
German encyclopedia
illustration, reproduced
same size.)

Influences of choice

There are many factors influencing the choice of printing technique. Each factor influences the others and all must eventually be influential. Consider, before you start, which factors are most important and allow them to modify subsequent decisions. Although it is better to establish careful working procedures and methods, these should not be inhibiting. Whilst employing care and patience to obtain results, experiment. 'Controlled discovery' will develop skills and extend the range of possibilities of creative expression through print, which provides the artist-designer with a unique experience of a distinctive range of media.

USE
This is really the most important aspect of selecting the print method. What you intend to use the print for very much influences your decision. It may be utilitarian – a poster, pamphlet, broadsheet, or publication to announce an event or idea. It may be an expression of your artistic abilities – a 'fine print' produced to enable you to duplicate a graphic statement in a manner which is further advanced than pencil drawing or painting. It may be experimental – the results influencing the subsequent development of your work. What you do with the prints once produced is of utmost importance in how they should be judged.

AVAILABILITY
Some methods, such as linocuts, can be produced in your home while others require studio or commercial facilities. Some processes, such as stencils, have simple tools and printing methods; others, such as lithography, require permanently established equipment. Consider whether you will be producing further designs before purchasing expensive equipment. With studio techniques, try to visit a school or college, or artists' print shop, and discuss with a professional practitioner the problems of your intended work before embarking upon the production. Whichever process you adopt, the basic principles of work apply; keep each work area separate – the preparation of the plate or block, the printing, the storing of equipment and paper. Clean up after each printing session and never leave inks uncovered after use. Clean all printing tools after use. Store any dangerous chemicals or solvents appropriately.

QUANTITY
Certain methods are more suitable for large editions than others. The two factors influencing choice of method are: extent of labour involved in printing large quantities and the possible deterioration of the block or plate during the printing of an edition.
Remember always to print in excess of your needs to ensure that damaged or faulty prints can be rejected. Poor results must not be included in an edition but should be destroyed.

COSTS

Costs are calculated by a very simple method whatever the print process. When estimating the cost of an individual print, the formula to use is to add all the initial costs, the materials, and the time of production, to form one total expenditure. Then divide this by the number of copies in the edition. Costs of your skills, artistic merit or troubles involved in the production are hard to quantify, but are factors to take into account in establishing the sales price of a print.

When you are producing numerous designs, the cost of tools and materials, other than paper, are not included in the costs as these are an investment and cannot be placed against one edition.

QUALITY

Fine prints, that is prints produced as an equivalent of a drawing or painting, should be printed on good quality paper. All test prints or imperfect proofs should be destroyed. Each of the individual copies of an edition should be marked in pencil with the number of the print, that is its number in the order of printing and the total edition printed. For example, 12/25 is the twelfth print of an edition of twenty-five copies.

Great care must be taken to ensure that each print has wide adequate margins which are totally free of dirt or accidental ink marks. Each proof should be identical to the others in the edition, unless the artist wishes to explore the variants.

COLOUR

Colour is normally achieved by additional blocks or plates. This requires you to proof the total edition in the first colour then, with care over register, print the subsequent colours in turn over the preceding ones. For example, a three-colour print of an edition of 200 copies means that each print has been printed three times, so that you have made 600 impressions by hand or on a press.

Monochrome editions can have attractive colour effects added by either printing in coloured ink, or on coloured paper, or both.

Adding transparent areas of colour by hand is also satisfactory if the paper is strong enough to hold the paint without distorting the surface.

Whichever method is used, care must be taken to try to ensure that the edition has a matching effect on all copies.

CONVERTING YOUR DRAWING

Most print techniques require you to transform the qualities of a drawing into those of another medium. The most extreme, stencilling, requires the drawing to be pre-organised into independent areas of flat colour. Lithography most easily duplicates the pencil, ink and brush marks of conventional drawing.

Before selecting a method of printing, it is wise to examine other artists' work in that media to understand what is possible when transferring your work to the plate or block. Once familiar with a method of printing, experimental techniques will widen your experience of the process and offer you further opportunities for development.

influences of choice

Each printing method has its advantages and disadvantages. It is important to consider these before embarking upon your design. Some require limited skills (linocuts and stencils); others require practice to produce satisfactory results (engravings and lithographs). Some require the minimum of tools (rubbings and rubber stamps); others require very specialised tools (the intaglio process of mezzotint). Before beginning your design, try to examine other examples in the media so that you can evaluate the possible opportunities. Many processes can be practised at home and often the discoveries in one help you to appreciate the techniques of another. You will find yourself working more comfortably with one medium than another and, once you have mastered the method, you can go on to explore its wider possibilities. Try always to attempt simple designs for the first encounter with a process as you can be very frustrated and disappointed if you begin overambitiously and the printed results do not achieve your intentions.

Advantages	**Disadvantages**
Monoprints (pp 36–7) Can be done at home. Good for exploring the impression qualities of ink on paper.	Each print is an individual result of work on the plate so duplicate identical prints are not possible.
Marbling (pp 38–9) Can be printed at home. Inexpensive and possible to produce excellent colour effects. Each print unique.	Cannot do very large prints and only abstract designs possible.
Stencils (pp 40–3) Can be printed at home. Inexpensive. Can produce flat colours and easy-to-master skills.	Designs must be simple. Requires care in printing as stencil wears out during use. Not suitable for large areas.
Rubbings (pp 44–5) Attractive as wall decorations. Require little skill.	Limited to source of engravings and each print is laborious to produce. Makes no demands on creativity.
Rubber stamps (pp 46–7) Inexpensive. Can print at home. The individual block can be used for repetitious all-over designs or assembled images by duplication of one element.	Designs must be simple. Hard to achieve a series of identical prints either from one block or the assembly of repetitions of one block.

Advantages	Disadvantages

Collage (pp 48–9)
Can be printed at home by burnishing. Inexpensive. Innovative materials create new ideas. Good for exploring patterns and texture.

Can be repeated only if printed carefully and made with durable materials.

Linocuts (pp 50–65)
Can be printed at home by burnishing. Easy to print and easy to learn the skills of block cutting. Proofs can have colour added by hand.

Design must usually be simple. Hard to produce tonal gradations other than by stipple or cross-hatching methods.

Woodcuts (pp 70–3)
Like linocuts, can be printed at home by burnishing but more permanent and finer lines can be achieved. Block offers textural opportunities. Normally able to combine with text in printing.

Requires special tools and skill in handling tools. Difficult to obtain large flat areas of colour. Unsuitable for very fine details unless the more expensive close-grained wood is used.

Wood engraving (pp 74–7)
Can print at home. Excellent for fine details. Often combined with text in book illustration.

Unsuitable for large designs. Expensive to purchase blocks. Requires specialised tools and skill in cutting with unusual tools.

Intaglio (pp 84–119)
Etching, engraving, etc. Very good for small detailed drawings. Etching has a line quality like drawing with a pen. Conventionally an artist's medium. Suitable for fine detail or broad tonal areas achieved in aquatint or mezzotint.

Needs studio facilities. Traditionally a monochrome medium. Size of work limited by size of press available.

Lithography (pp 124–33)
Excellent for gradated tones as you can work direct onto the plate. Pencil, brush and ink marks can be achieved exactly.

Requires studio facilities. Expensive to install press and equipment.

Screen printing (pp 134–45)
Excellent for large areas of flat colour. Good for large sizes (posters) and for application to surfaces other than paper. Excellent for large editions.

Requires studio facilities. Cut stencils unsuitable for very fine detail. Screen fillers are more versatile. Simple hinge gears and printing frames can be made or purchased from suppliers as an alternative to professional machines.

Printing papers

Papers are produced in hundreds of different sizes, thicknesses, strengths, colours and surfaces. There are five factors influencing your choice of paper: the surface quality; the strength; its colour; the quality of the ingredients and its cost. Always obtain a sample before ordering a large quantity, and keep a drawer of your desk for examples you have used and found satisfactory. Generally, heavy papers and hand-made papers are more expensive than thinner ones or machine made ones. Keep a stock of poorer quality, cheaper papers for test prints, but always print your total edition on the best quality paper you can afford and which is appropriate to the print medium employed.

Weight; expressed per 500 sheets or grammes per square metre (gm^2), but, as sheet sizes differ, this can be confusing. Always judge the paper by a sample, never by a specification.

Size or **sizing;** the amount of water-resistant agents in the paper.

Coating; a surface layer of material which creates a smooth finish.

Hot pressed; refers to the paper surface, normally a fine smooth texture, achieved by drying with rollers during manufacture.

Deckle edge; an uneven edge originally the result of making the paper in a hand-held tray.

Japanese papers; very expensive papers often with natural fibres embedded in the surface.

Basic paper types, their character and uses

		MONOPRINTS	STENCILS	RUBBINGS	STAMPS	RELIEF COLLAGE	LINOCUTS	WOODCUTS	WOOD ENGRAVINGS	INTAGLIO PROCESSES	LITHOGRAPHY	SCREEN PRINTING
Mould-made and hand-made papers	Often used for watercolour painting. Heavy weight, will soften when dampened.						●	●	●	●	●	●
Waterleaf papers (unsized hand-made, hot pressed papers)	Absorbs ink well and will take a larger number of printings. Fragile and needs to be handled with care when damp.						●	●	●	●	●	●
Smooth surface, hand-made papers (mould-made and hot pressed papers)	Takes ink well, good for relief or surface impressions, either intaglio or screenprinting.	●					●	●	●	●	●	●
Commercial printing papers	Not suitable for damping. Usually not strong enough to take impressions from hand intaglio presses.	●	●	●	●	●	●	●	●		●	●
Newsprint	Thin, tears easily, not suitable for damping. Good for trial proofs.	●		●	●							

Preparing for press

All proofs must have a margin of white space around them so calculate your paper sizes in excess of the image size. Do a careful calculation of the number of sheets required and prepare these for your edition, allowing 10% extra to compensate for loss during printing (faults, mis-register.).

Proofing paper

Printing involves exploring the effects of your master image (the block, plate or screen), so it is useful to have a stock of cheap paper available for tests. Also, store newspapers to use in clearing up and placing on work surfaces.

Grain

Paper is an assembly of small particles of wood, rag, chalk and size, which, during drying, arrange into a common direction – the grain. To establish which way the grain is, tear a strip off two adjacent edges. The strip with the smoothest tear is the one in the direction of the grain.

Sizes

Manufacturers have hundreds of different sizes, each for different printing machines, specific uses or binding machines. American sizes vary considerably from European sizes. The majority of European sizes have been standardized to ISO A series but these do not apply to many printing machines so larger sizes are used and trimmed.

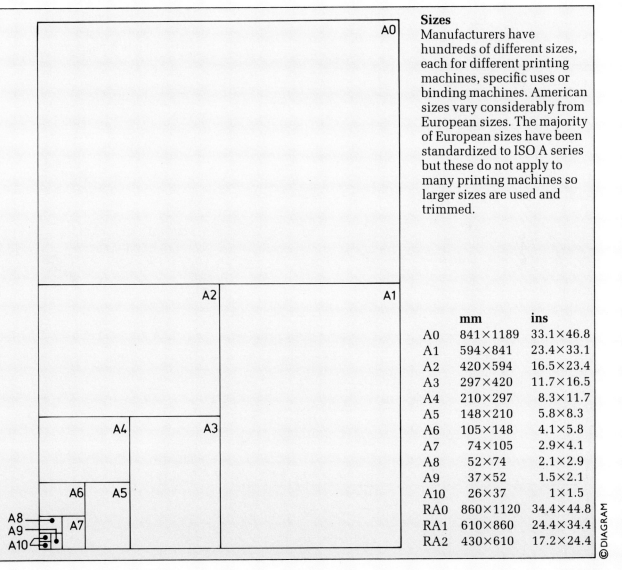

	mm	ins
A0	841×1189	33.1×46.8
A1	594×841	23.4×33.1
A2	420×594	16.5×23.4
A3	297×420	11.7×16.5
A4	210×297	8.3×11.7
A5	148×210	5.8×8.3
A6	105×148	4.1×5.8
A7	74×105	2.9×4.1
A8	52×74	2.1×2.9
A9	37×52	1.5×2.1
A10	26×37	1×1.5
RA0	860×1120	34.4×44.8
RA1	610×860	24.4×34.4
RA2	430×610	17.2×24.4

Changing the size

One of the most likely things you will want to change is the size of your original drawing when you have chosen your print method. As a simple guide to changing size, remember that the diagonal of both the original and your new design will have a common angle. It is of course only necessary to copy out the major elements of your design and then, by eye, to fill in the details. Working with the image upside down can help you to observe the shapes more accurately.

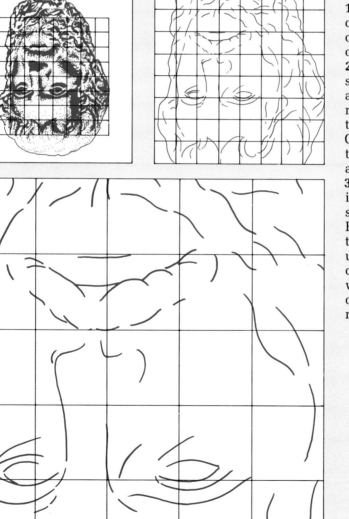

Enlarging by squares
1 Draw a pattern of squares onto your original drawing, or on a protective tracing overlay.
2 Draw the same number of squares onto an enlarged area ensuring that the resulting larger rectangle is the same proportion.
Copy out the patterns of the original drawing as they appear within each square.
3 For further enlargements, increase the size of the squares.
For close detail, subdivide the squares into smaller units. By working with the original upside down, you will be more likely to observe only the shapes and relationships.

Enlarging by dividers

Using proportional dividers, adjust the centre screw to a place on the length of the dividers so that the distance between the long legs (**a**) is the required enlargement of the distance between the short legs (**b**). The dividers can then be used to transfer any dimension to its new proportional size.

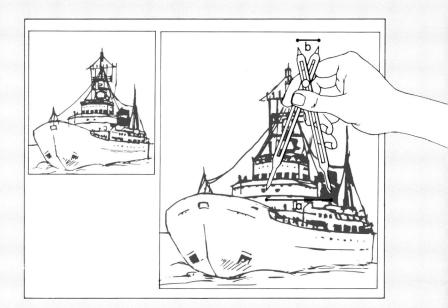

Enlarging, reducing machines

Most print studios have an enlarger which operates very much like a vertical camera. The original drawing is placed on a movable base plate. This and the lens can be adjusted to vary the size of the image on a viewing plate above.

Enlarging by pantograph

A pantograph can be adjusted to a required changing ratio of sizes and then used to follow the outlines of the design to a new size. This method is usually not very accurate as controlling the two ends of the moving arms requires you to watch constantly two differing points on your work – the one on the original and the other on the newly-plotted-out design.

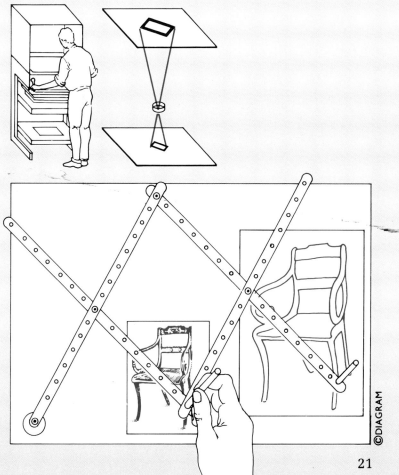

©DIAGRAM

21

Converting your drawing

Aside from your skills in drawing and your cultural vision of an image, the strongest influence of the form of your work is the method by which you choose to print the drawing. Some methods require simple solutions without any opportunity for detail; others enable you to explore the tones and details of your work. Each printing method requires its own form of interpretation.

A

B

C

Variations in form
Seven examples of the same subject, an elephant. Each reveals a feature of the method of reproduction. All are reduced in size with the exception of **2**.
1 A paper punch design
2 A wood engraving
3 A hand block
4 An etching

5 A rubber stamp design
6 A woodcut
7 A stencil design

Converting a drawing
As an exercise, try to convert one of your drawings to a form suitable for the method of reproduction you intend. The pencil drawing (**A** *above*, reduced) can only be

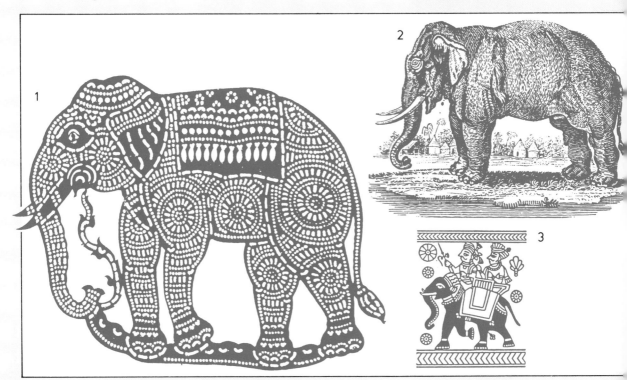

D

E F

G

satisfactorily printed by lithography. The pen drawing (**B**) could be suitable for either etching or engraving. The next two drawings (**C** and **D**) could be cut from lino or wood. (**E** and **F**) could be produced on a stencil or silkscreen. To produce a stamp print, cut from lino or rubber, a much more simplified design would be necessary (**G**). When working your ideas, try to vary the quality of the lines by using drawing implements. Drawing (**A**) was done in pencil, (**B**) with a pen, and the others with a felt tipped pen.

Try to spend more time exploring the image you wish to achieve, working in black and white paint, before you begin to work on the block or plate. Paper sketches are easily and inexpensively adjusted. Working directly onto the block can be costly and hard to adjust.

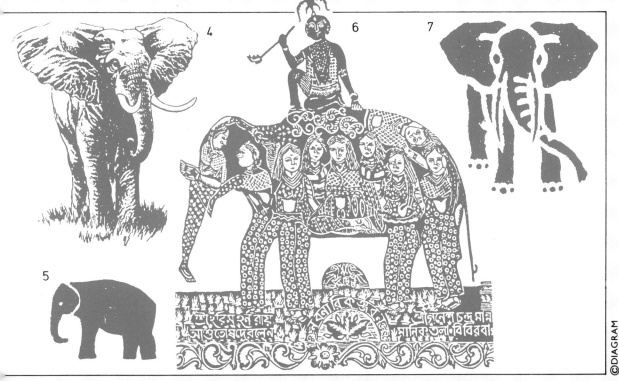

4

6

7

5

Using photographs

A

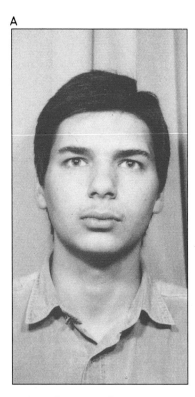

B

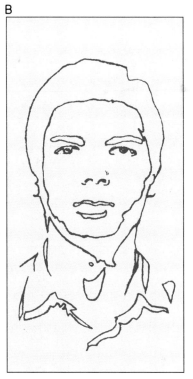

C

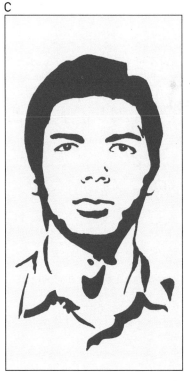

Using photographs

Photographs often make an excellent starting point for producing an image. To reproduce a photograph as above requires commercial techniques which are expensive and influence the choice of paper and printing method. Elements of a photograph are also constant, but a drawing offers you the opportunity to vary the tones, shapes and proportions of the image. You can either do a direct conversion, or use a photograph as a memory aid while doing a drawing.

Conversion techniques

Begin with a photograph (**A**) which is large enough for you to see details when you trace it onto paper with a soft pencil. Follow the edges of tone between the darkened areas and the lighter ones (**B**). Your conversion must create contained areas where the line surrounds dark parts only. Then fill in the areas, watching carefully that you ink in only those areas which are dark in the photograph (**C**). Although this method ignores normal drawing skills, it can produce successful images which are more easily reproduced.

Memory aids

The etching (*far right, reduced*) contains a great deal of detail which was derived from a study of photographs of the interior of the church.

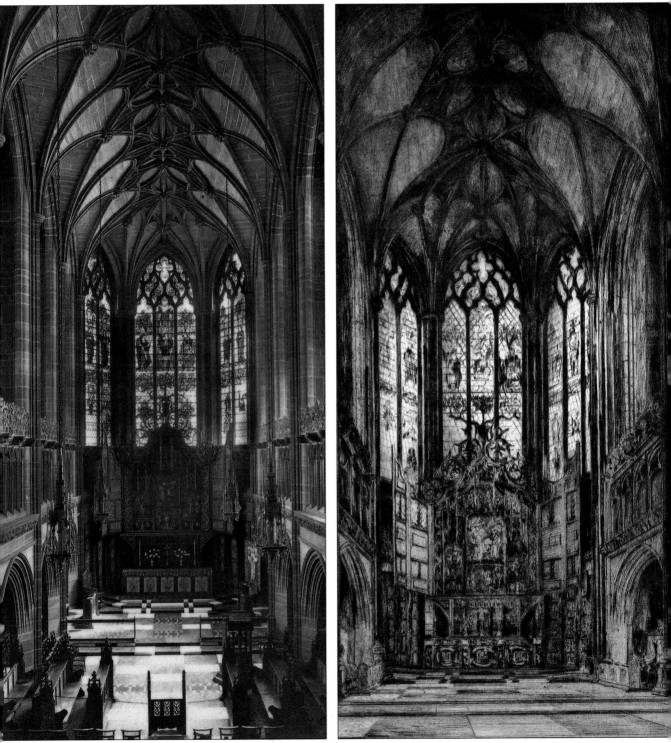

25

Exploring ideas

Printmaking has traditionally been used by artists to explore graphic forms and qualities. Remember that the prime object of exploring these techniques is to enjoy being inventive. Discoveries made while working freely with the media can be used in the production of your later work and any accidental results obtained offer you a bonus which will broaden your views of your work.

Experimental prints
The collage (*right*, reduced) explores the effects obtained with textured materials stuck to card. Having judged their qualities in this form, they can be applied to more conventional drawings.

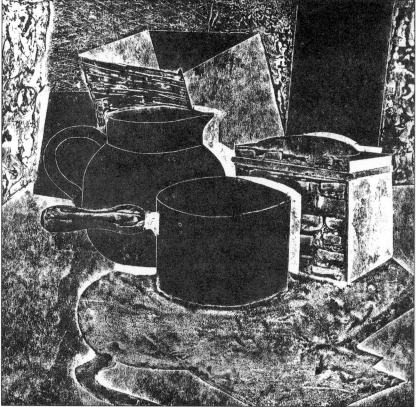

Test blocks
The linocut (*above*, reduced) was produced to illustrate the qualities of various blades and cutting techniques. Exploring these helps you resolve your drawing possibilities when beginning a linocut. Note areas of counterchange, i.e. white lines/shapes on black, black lines/shapes on white.

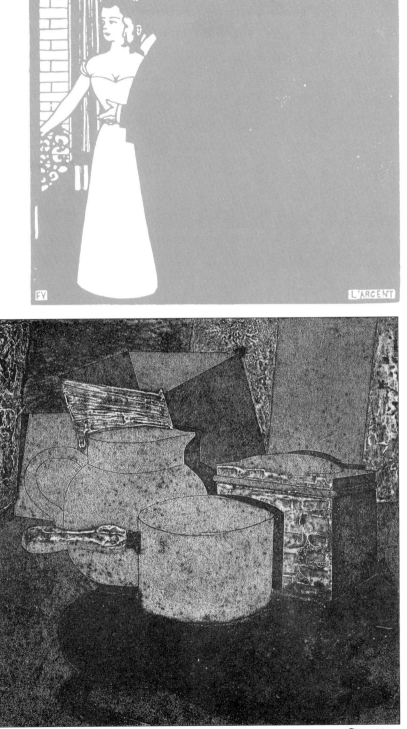

Design experiments

This woodcut (*left*, greatly reduced) explores the effects of an extreme composition. The large dark area of solid printing creates tensions in the design and directs you to the small details of the two faces and hands.

Exploring printing

Both proofs (*left*, reduced) were taken from the same block. The original is cardboard scored with a dull point, with layers removed and quick, hard-drying pastes applied to some areas. The image (*far left*) is printed by inking the raised surface and by relief printing technique. The second (*near left*) is inked, then wiped clean so that the lower areas retain the ink and the result is printed as an intaglio etching.

©DIAGRAM

Repeat patterns

Repeat patterns are most frequently used when the area of the design is smaller than the total area on which you want to print. There are numerous methods of achieving a repetitious design. These two pages illustrate the single image repeat and the multiple image repeat. The next two pages illustrate the 'all-over' design solution.

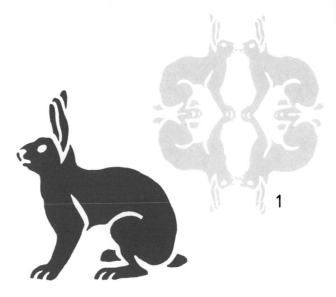

Single repeats

1 A simplified design, the rabbit, can be traced and repeated in its mirror image form. When these are combined, they form a complex unit with its own design qualities.
2 The image may be flipped to form a unit which is then repeated.
3 The single image may be positioned in a repetitive order over a simple grid. Care must be taken to ensure that all the images are correctly aligned and equidistant.

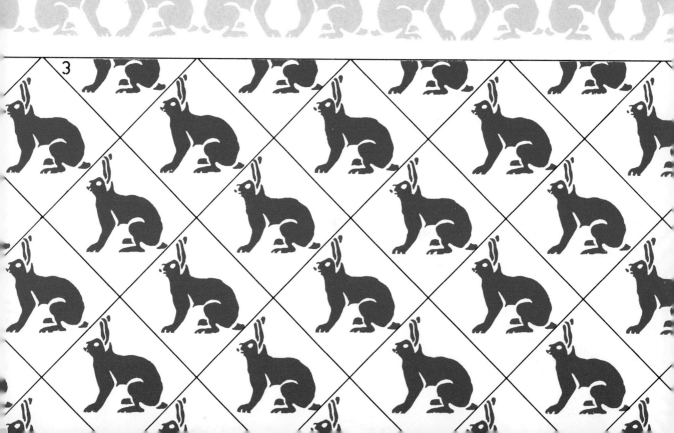

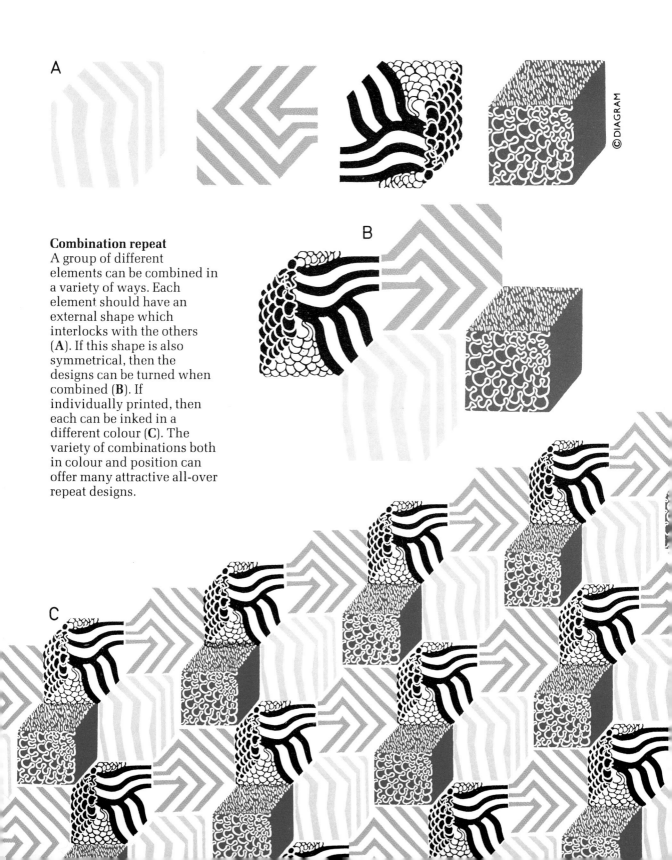

A

B

Combination repeat
A group of different
elements can be combined in
a variety of ways. Each
element should have an
external shape which
interlocks with the others
(**A**). If this shape is also
symmetrical, then the
designs can be turned when
combined (**B**). If
individually printed, then
each can be inked in a
different colour (**C**). The
variety of combinations both
in colour and position can
offer many attractive all-over
repeat designs.

C

repeat patterns

'All-over' printed designs are devised to conceal the single unit from which the pattern is produced. This can be either by interlocking a master image so direct divisional lines are not apparent, or by constructing a unit in which the key design has been redistributed.

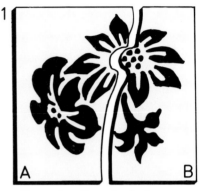

Regular patterns (*below*)
When the design elements are very small in relationship to the area covered, rather than print each element singly, they can be combined into a large unit, and printed in an interlocking manner.

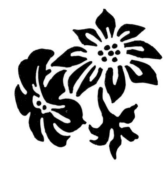

Repeat pattern techniques
When it is necessary to obtain an all-over pattern, you must adapt your design to achieve an integrated solution.
1 Draw an accurate square around your design and cut it into two vertical pieces along an irregular line.
2 Transpose the two parts and stick them together.

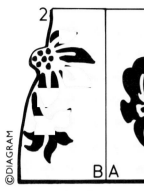
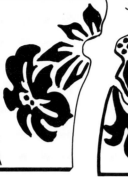

2

3 B₁ A₁

4

B₂ A₂

A₂ A₂
B₁ A₁

B A

5

3 Cut the new shape into two horizontal halves, along another irregular line.
4 Transpose the two parts and stick together.
5 Fill in the centre area with linking motifs. Print the newly-constructed master element in a repeat form, ensuring that the edges of each printing match up together. The repeat element contains sections of the original motif and, when combined in printing, re-establishes the motif.

Part Two

WORKING AT HOME

Work areas

Working at home can be achieved with very little space or equipment. The important requirements are: good lighting and ventilation; access to water; drying and storing space for prints; storing space for tools and inks; and a large dustbin fitted with a lid and plastic liner for waste materials, dirty cleaning rags, etc. Work surfaces can be made from old doors which are supported on cabinets or wall brackets, and surfaced with hardboard, linoleum or plastic sheeting.

Some key points
- Clean all your surfaces after use.
- Keep planning, cutting and printing areas separate.
- Keep all surfaces clear of other tools and objects.
- Constantly discard waste paper.
- Ensure the floor is easy to clean. Linoleum or bare wood is best.
- Keep a small fire extinguisher at hand.
- Keep water away from your drawing area and print area.
- Remove all waste paper and cleaning materials soaked with solvents from the workroom on completion of work.

A permanent planning area
1 Your light sources should fall on the opposite side to your normal working hand.
2 The drawing board surface should have a slight slope and be strong, heavy and stable.
3 Pens, brushes, pencils, should be stored away when not in use.
4 Comfortable chair of a convenient height to avoid fatigue.
5 A portfolio or plan chest to store drawings and prints.

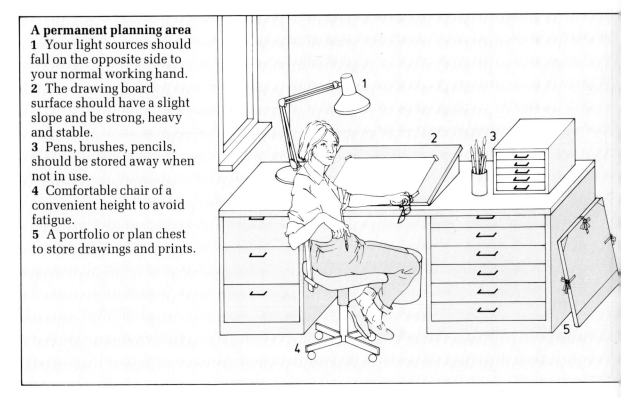

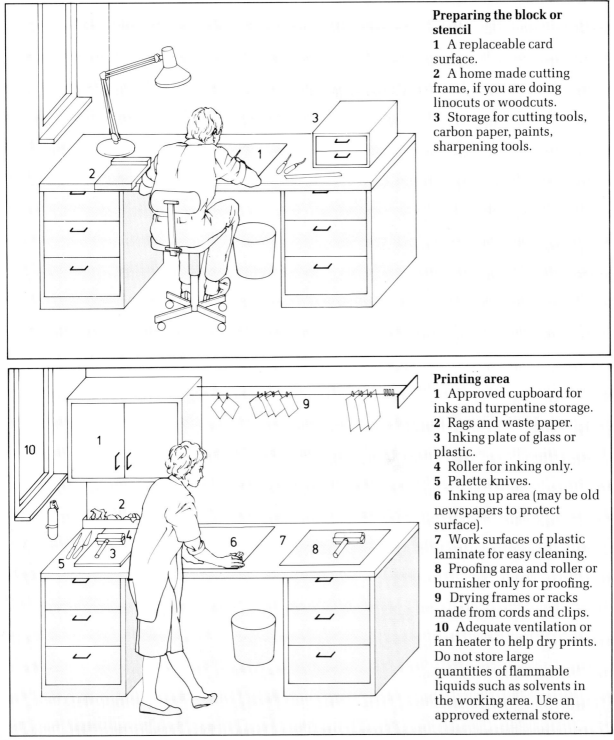

Preparing the block or stencil

1 A replaceable card surface.

2 A home made cutting frame, if you are doing linocuts or woodcuts.

3 Storage for cutting tools, carbon paper, paints, sharpening tools.

Printing area

1 Approved cupboard for inks and turpentine storage.

2 Rags and waste paper.

3 Inking plate of glass or plastic.

4 Roller for inking only.

5 Palette knives.

6 Inking up area (may be old newspapers to protect surface).

7 Work surfaces of plastic laminate for easy cleaning.

8 Proofing area and roller or burnisher only for proofing.

9 Drying frames or racks made from cords and clips.

10 Adequate ventilation or fan heater to help dry prints. Do not store large quantities of flammable liquids such as solvents in the working area. Use an approved external store.

Monoprints

Monoprints are unique printed images, not multiple repeats of an original image. Very little equipment is required: only a flat surface, inking roller, burnishing roller and inks. The method is employed to explore freely ideas, images and the range of drawing qualities possible in print, using monochrome or colour.

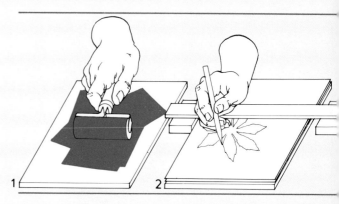

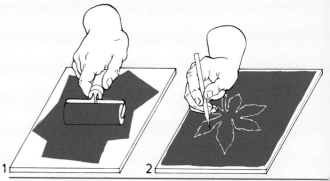

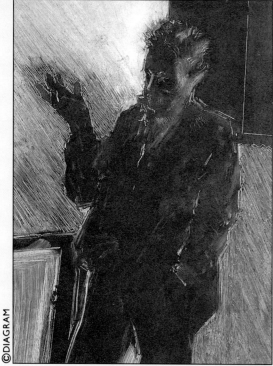

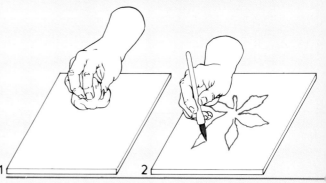

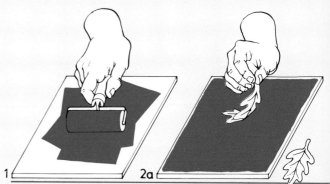

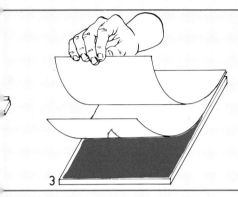

Direct method

1 Ink a smooth, clean, flat surface with an even layer.
2 Place the paper on the inked surface. Then place your design on top, and redraw it with a pencil or pointed stick, taking care that only the drawing tool comes in contact with the surface. You can rest your hand on an improvised bridge of a ruler and block support while working.
3 Gently remove both papers and the design will be printed on the reverse side of the lower paper. This method is good for duplicating the granular effects of a pencil line.

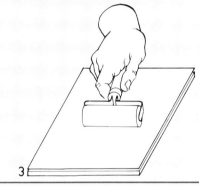

Subtraction method

1 Ink as above.
2 Draw directly onto the surface with a point to create white lines. A range of marks and tones can be achieved by scraping out areas of the ink with card, or wiping with a rag dampened with solvent. This gives bright clean areas, dry rags give grey areas. You could add a little linseed oil to the ink. This allows the ink to be worked longer on the plate and releases ink more easily.
3 Cover with paper and burnish with a roller. This method cannot be used to produce duplicate images as each impression has to be redrawn. Example (*far left*) reduced, detail actual size.

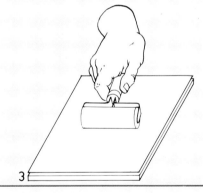

Additive method

1 Begin with a clean plate which is wiped free of grease or water and ready for oil-based inks.
2 Draw or paint on the surface with slowly-drying inks which can be diluted with linseed oil. Damp plate with turps.
3 Place paper on the surface and roller burnish. This method offers opportunities for tones and gradated effects, but each impression must be newly drawn, so you cannot produce duplicate images.

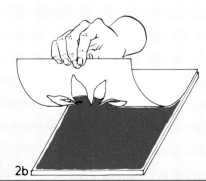

Object method

1 Ink up as above.
2a Place an object or objects, such as leaves, paper doilies or cotton thread, onto the pre-inked surface and print as usual. The objects may stick to the paper but these can be removed when dry to reveal white areas.

Stencil method

1 Ink up as above.
2b Place a paper stencil on the inked surface and print as usual. Only the exposed areas of the stencil will print. This method is good for achieving a series of similar designs.

Marbling

Marbling effects are achieved by laying paper onto a thin layer of oil-based paint which is floating on the surface of a water-based gum, e.g. gum arabic, or a solution of heavy-duty wallpaper paste. Each print has its individual characteristics but a series of similar prints can be achieved. Marbling requires few tools and is easily mastered.

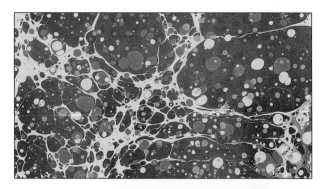

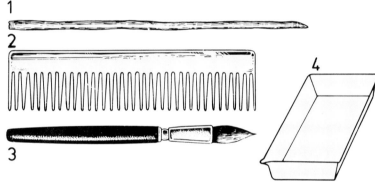

Tools
1 Needle or stick to stir paint surface.
2 Comb to wire-wipe surface.
3 Brush to apply paint.
4 Tray for water. The size of the tray determines the maximum size of the print.

Procedure
Begin by diluting with turpentine small bowls of various colours of oil paint.
1 Fill a tray with a shallow depth of water and drip-drop the colours onto the surface.
2 Gently stir the surface, avoiding disturbance of the paint which will cause it to sink or mix into the water.
3 Regular parallel patterns can be achieved by combing the surface.
4 Carefully lower a sheet of paper onto the surface. Do not disturb the paint, and avoid air bubbles by laying the paper from one corner.
5 Carefully remove the paper and lay aside to dry.
6 Skim the surface clean of paint with a piece of card and begin again.

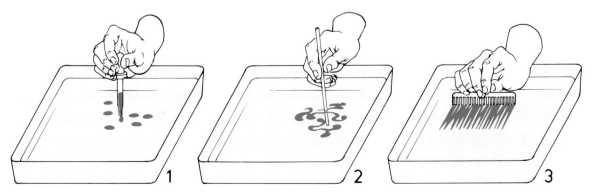

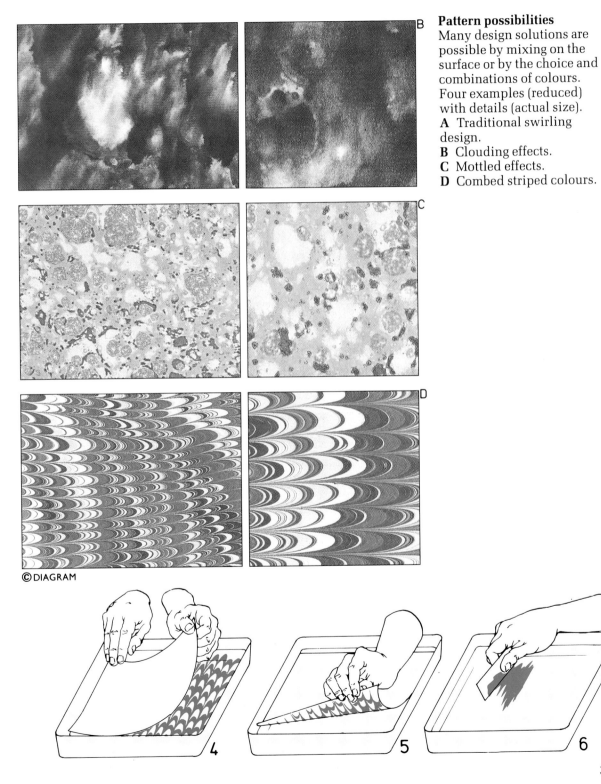

Pattern possibilities

Many design solutions are possible by mixing on the surface or by the choice and combinations of colours. Four examples (reduced) with details (actual size).

A Traditional swirling design.
B Clouding effects.
C Mottled effects.
D Combed striped colours.

©DIAGRAM

Stencil prints

Stencilling is a method of transferring a design onto paper by pressing paint through holes cut in a protective surface of card, paper, metal or similar material. The design must consist of individual holes, separated by bridges of protective material, which produce a characteristic feature of stencil prints. Very few tools are required and the printing method can be practised at home. Stencils can be very large, but small stencils are hard to produce with fine details.

Tools
1 Pencils to transfer down the design.
2 Cutting tools; either artists' knives or scalpels. Inking tools can be of various types:
3 Sponges; for dabbing inks onto the surface.
4 Flat-headed stencil brush; for dabbing inks through stencil.

5 Spray diffuser; for spraying inks through stencil.
6 Roller; for inking flat areas.
7 Old tooth brush; for splattering inks through stencil.

Converting your drawing
Stencil designs require you to transform your drawings into flat, simple, patterned areas. Each area needs to be held in position by bridging supports of sufficient thickness to hold the design together, and broad enough to prevent colour from seeping under them when you are inking your design.

Cutting materials
Stencils can be cut from thin card, metal, plastic or oiled paper. Whatever the material is, it must be water-resistant, so that you can clean the stencil after use, and strong enough to hold up against the printing technique.

©DIAGRAM

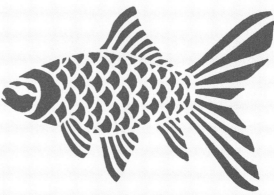

Oiling paper

Normal paper and card can be preserved by the application of a mixture of 50% boiled linseed oil and 50% turpentine. This mixture can be rubbed into the paper and, if you are making a batch of stencils, each can be dried by laying them between sheets of newspaper so that the surplus oil is absorbed and then hung to dry.

Cutting the stencil

After tracing down your design onto the stencil material, begin by cutting out the smaller areas. Try to avoid cutting beyond the end of an edge with the blade, as this can cause trouble later in printing. The largest areas should be cut last to ensure that the strength of the stencil is maintained during cutting.

Inking a stencil

This offers opportunities for flat, regular colours or gradated areas, or areas of differing colours.

41

stencil prints

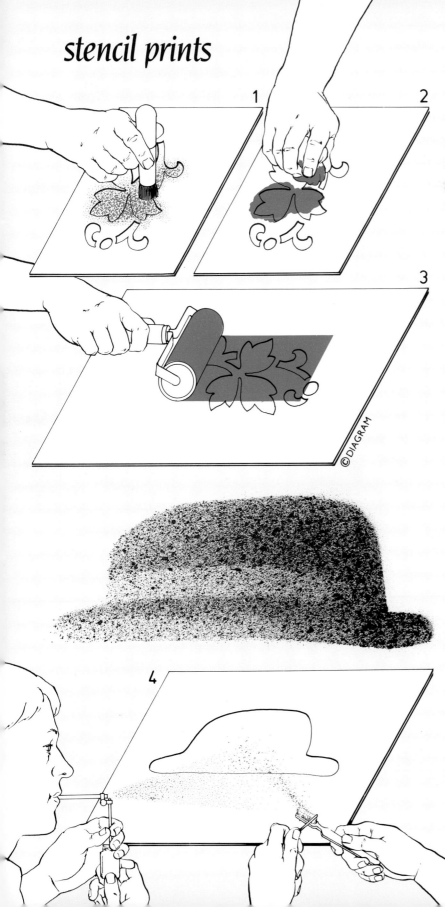

Printing

Whatever method you use for applying the ink, it is always best to apply a number of thin layers rather than one thick one. The stencil must be held firmly in contact with the paper surface, to avoid seepage under the edges. Always ensure that the surface touching the paper is clean and has no ink on it from earlier proofs. It is vital that the ink has an even consistency, and is evenly spread on the inking palette.

Brush inking (1)

The brush leaves a mottled impression, so the areas must be built up to the intensity of colour required by dabbing with the brush.

Dabbing (2)

First test the results on scraps of paper to avoid excess ink and to prevent any overinking marks.

Roller inking (3)

This is the most common method of obtaining regular, flat areas of colour.

Spraying (4)

You can use a fixative diffuser, obtainable from an art store, or an old tooth brush. Both are suitable for use with indian ink or well-mixed, diluted gouache. When spraying, protect all the surrounding areas to prevent side spray on the edges of the print.

Coloured stencils

Interesting effects can be achieved by cutting different areas of the design on separate stencils, and printing each in a different colour, or printing colours on separate parts of one stencil. It is often very attractive to vary the textures of colour and to explore the effects of overprinting. The card-cut stencil (*right*, actual size) was printed in five colours from four stencils.

Register of colours

For correct registration of colours, first prepare all stencil sheets by cutting to the same size and then placing on top of each other with edges aligned. Cut V incisions through all sheets. When printing the first stencil, ink the incisions allowing for correct registration of subsequent stencils. When printing, ensure that each colour is dry before printing the next, or colour will stick to the back of the stencil.

Pattern stencils

Because stencils are cut from thin strong materials, they are suitable for printing onto curved surfaces. If areas are sufficiently divided, then other colours can be inked onto the one stencil. Repeat patterns need a guideline to ensure their regularity, and the best way to achieve this is to set all printings along the base or top of your stencil. If clear acetate is used, registration of pattern and colour is made easier.

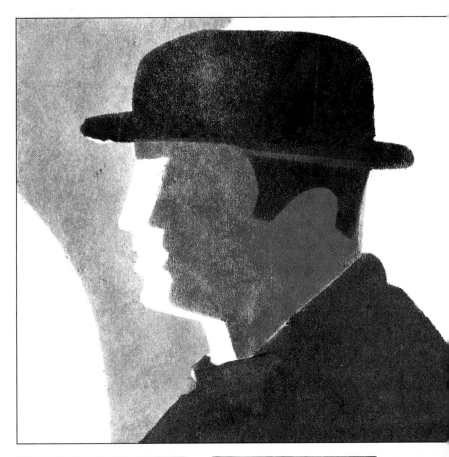

Rubbings

Rubbing is a very simple method of producing a series of similar images. It requires only thin paper and a wax or graphite pencil. Large rubbings from existing stone or metal decorations make excellent wall hangings or framed pictures. Experimental rubbings from small objects are often incorporated in other graphic media.

Tools
1 Cobblers wax; a strong bar of wax available in a number of colours.
2 Graphite sticks; available from good art shops.
3 Lead pencils; used on small designs such as coins.
4 Weights; to hold large paper when working on existing carvings.
5 Broad brush; to preclean the grooves of carvings.

Establishing an image
Hold the paper firmly in position with one hand or with weights (**A**) and lightly follow the edges of the design with a wax (**B**). Apply heavier pressure over the total area, building up an even image (**C**). Care must be taken not to overapply the wax as in (**D**). The final result should have an even, all over texture (**E**) and all the white lines should be clear and sharp.

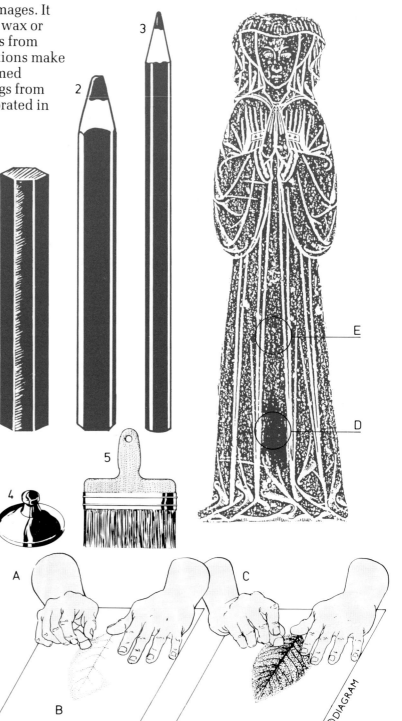

Traditional sources
Engravings in metal (*left*, reduced) or stone (*above*, reduced) offer ideal subjects for large-scale rubbings.

Experimental sources
Almost any flat object which has a surface texture can be used. The autumn leaves (*right*, reduced) reveal their fine structures when 'rubbed'.

Constructed sources
Sticking small objects onto card in the form of patterns helps build up compositions which can then be rubbed. The paperclips (*right*, reduced) were arranged to make designs later used on a Christmas card, and rubbed with coloured pencils.

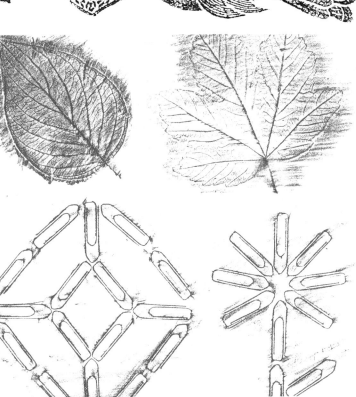

Stamps

Stamp printing is very easy to do. It is inexpensive, requiring little equipment, and no complex methods are involved to master results. It is very suitable for exploring the all-over repeat pattern designs but not suitable for achieving refinement of details. The stamp can be cut from many materials, depending on your carving skills.

A

B

C

Uses
Stamps can be hand-made and used as a device to repeat patterns (**A**), or for commercial purposes, made from your design as a franking tool (**B**), or as your personal seal on your more complex prints (**C**).

Surface applications
Stamps can print on almost any surface provided that the surface is not too smooth and resistant to ink, or too rough and not able to take the detail of the impression.

Materials
Stamp blocks can be cut from potatoes, or other hard vegetables, polystyrene, rubber, linoleum, wood, or any surface into which you can carve or add raised areas by gluing. The Turkish wood block (*far left*) is used on fabric printing and produces the design (*left*).

Method of production (right)
1 Cut the design away from the flat surface of the block. The raised areas left will form the design and print.
2 Ink up a flat surface such as glass or plastic.
3 Press the stamp onto the inked plate, ensuring that the surface of the block collects ink on all the raised areas.

4 Print the design in the required position.
The quality of the print very much depends on the inking and pressure during the printing, and the surface to be printed on.

1

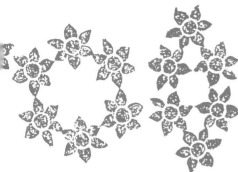

All-over designs

Simple patterns cut from potato (*right*, actual size) can be printed in a variety of combinations to produce all-over patterns (examples *above*, reduced).

Natural objects

Prints can be made from the flat surface of existing objects. This can produce unique and exciting results. Bottle tops, corks, keys and any flat industrial objects can be used. The prints (*right*, reduced) were obtained from a cut cabbage (**A**) and by inking a fish (**B**) and pressing paper onto its scales.

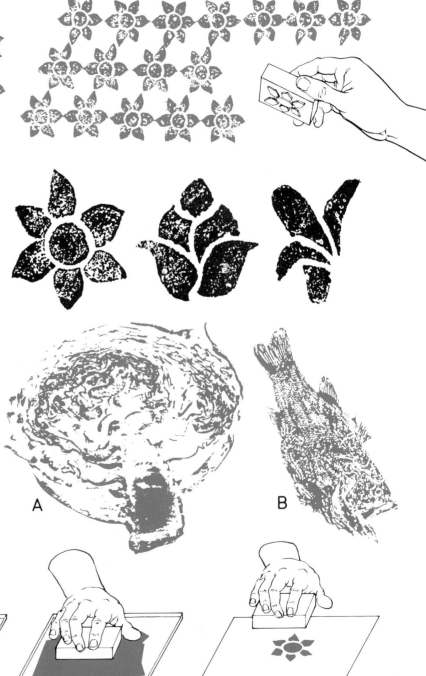

A

B

©DIAGRAM

Relief collage

Thin materials attached to a flat surface are inked with a roller and then printed by burnishing. This medium offers opportunities to explore a wide variety of textures and can be used to stimulate ideas. Almost any surface can be inked to create a printed texture.

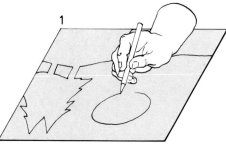

Design
String pattern motif (*left, reduced*). Because the materials are often difficult to control, create bold and simple structures.

Method
1 Draw the basic design in pencil onto card. A simple image avoids problems in handling, fixing and cutting

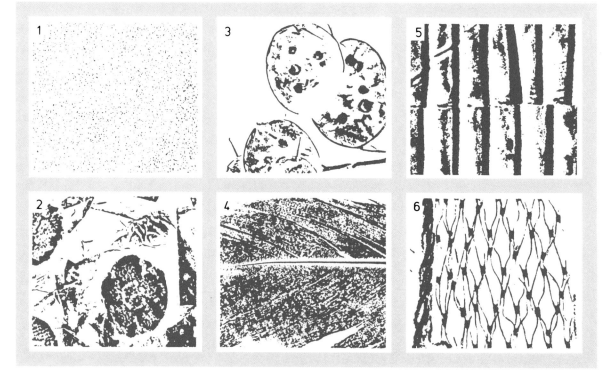

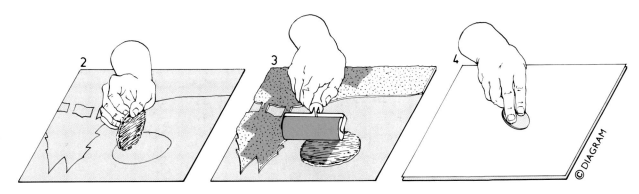

small or intricate pieces of collage material.

2 Test print materials to discover their tonal and textural qualities, then cut and glue to the card base those most suitable to your requirements. It is essential that they are of a similar thickness to obtain even inking of the block.

3 Ink up the design using a roller.

4 Place paper over the inked design and burnish with a smooth flat implement, such as a spoon or back of a comb.

Examples
A selection of prints (*below, actual size*) of found materials.
1 Sandpaper
2 Crumpled paper
3 Dried leaves
4 Feather
5 Inside cardboard
6 Plastic netting
7 Crumpled paper
8 String netting
9 Fabric
10 String
11 Artist's PVC paint applied thickly
12 Lace netting

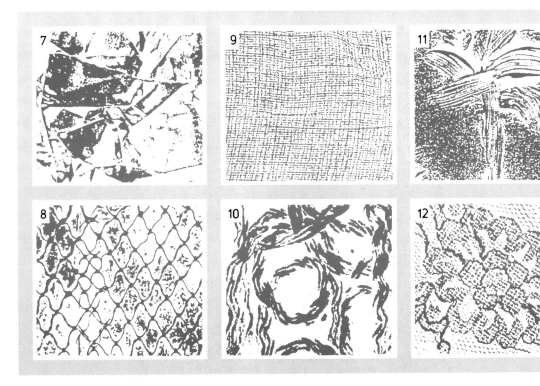

Linocuts: equipment

The basic principle of relief printing is that the white areas of the design are removed from the block. The areas left are inked and printed to produce the image. It is the easiest reproduction process to master as it requires only a few inexpensive tools, and offers a wide range of results. The method can produce up to 300 prints before the block begins to show signs of wear. Printing can be done by the simple technique of burnishing the back of the paper, or the lino block can be mounted on a wood base and printed in a normal relief printing press.

Linoleum
Use a good quality lino (**1**) with a canvas backing. A thickness of ⅜″ (0.95cm) is recommended to ensure that the lowered areas still give some support to the raised areas.

Tracing down tools
Carbon paper (**2**) and tracing paper (**3**) to transfer down your design. A soft pencil (**4**) for tracing down or drawing direct onto the block. White paint (**5**) and a brush (**6**) for painting the surface before drawing.

Cutting tools
Special linocutting tools (**7**) with a variety of nibs (**8**). A very sharp penknife or woodcutting knife (**9**), and oil (**10**) and oilstone (**11**) for sharpening the tools.

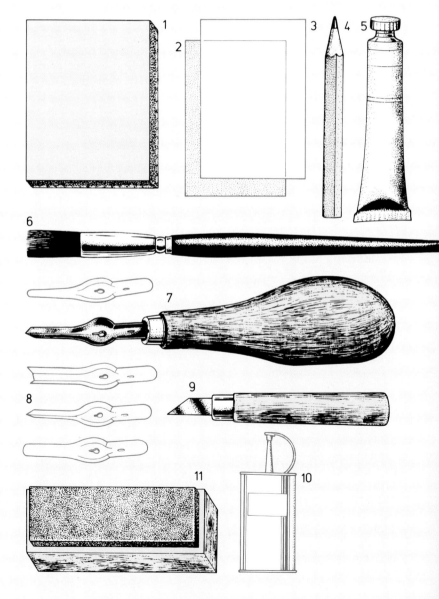

Cutting board

A home-made cutting board (**12**) helps maintain a steady position of the block when cutting away the design. This also improves safety as the block is less likely to slip during working. When cutting, keep both hands behind the cutting edge of the tool. Never cut towards yourself and change the position of the block on the cutting board so that the direction of the cut is away from you.

Inking equipment

A glass surface (**13**) for mixing the ink. A palette knife (**14**) to spread the ink, and either oil-based inks or water-based inks (**15**). The ink is applied to the raised surface by either a roller (**16**) or a broad flat-nibbed brush (**17**) or a dabber (**18**).

Printing

Lino blocks can be held in a printing frame (**19**) and pressure applied by a clean roller (**20**), or by a variety of burnishers like spoons or spatulas (**21**). Lino blocks can also be mounted on wood and printed in a normal relief printing press.

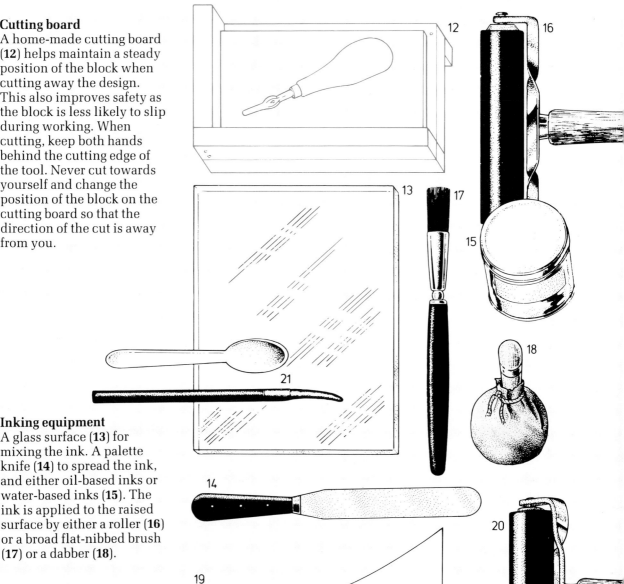

©DIAGRAM

51

linocuts: *converting your drawing*

Linocuts usually do not contain fine lines. The most successful are broad bold images. The print is a lateral reversal of the block. Therefore the tracing or drawing should be reversed left to right to bring the printed image back to its original position. This is particularly important if lettering is used. Grey tones can be achieved by linear or stipple cuts made in the appropriate areas after the main white areas and lines have been cut away. The areas cut away do not print, the remaining lines or shapes do.

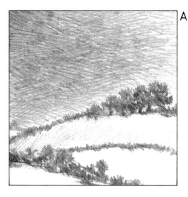

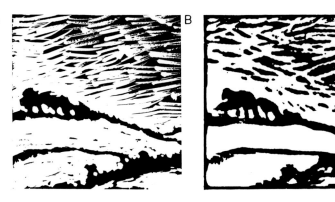

Converting your drawing
One successful way of converting your drawing is to redraw the original (**A**) onto black paper with white paint (**B**). This will more accurately emulate the quality of the final linocut (**C**).

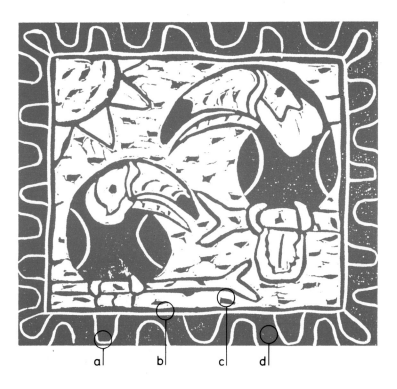

Linocut style
The style of linocut is often characterised by : freeflowing lines (**a**); no straight edges (**b**); support for large white areas (**c**); and no large areas of solid colour (**d**) which would be difficult to ink and print.

52

Preparing the surface

1 Wet the surface of the block, then rub with an abrasive paper. This gives a smooth surface which helps in achieving good solid areas of colour in print.

2 Paint the surface with a thin layer of white emulsion so that your work will be clearly revealed during tracing down and cutting.

Transferring down

3 The main features of your design can be sketched down onto the surface. If a tracing is made using brush, indian ink or felt tip, this can be reversed by flipping over the tracing paper before transferring to the block prepared with a white ground.

4 When it is necessary to work accurately from your original place it on top of carbon paper and over the block. Cover your original with tracing paper and then carefully follow the design elements with a hard pencil. Another method is to paste your original onto the lino and then cut away the white areas. This method ensures you have an accurate start to the cutting process.

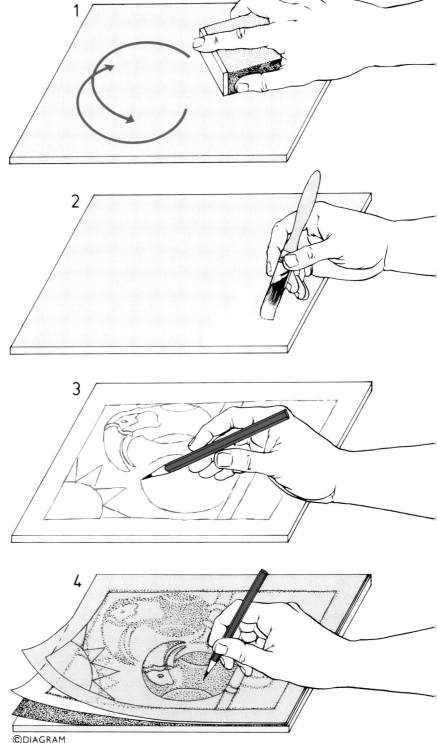

©DIAGRAM

53

linocuts: cutting lino blocks

Good cutting of lino blocks requires practice. Care must be taken to ensure that you cut away only the areas designated white as it is impossible to correct an error. As a basic rule, cut less away and gradually remove areas as you work. If in doubt, proof your design in stages as you develop the block. The shape of each blade produces differing cuts. Use the appropriate tool for large open areas or detail.

Detail (*above*) of a linocut in which large areas have been cut away to produce light areas. Care must be taken to prevent damaging the remaining ridges which print black.

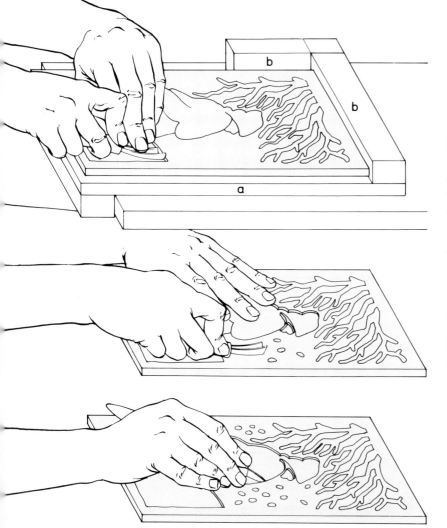

Beginning the cutting
If possible, cut with the lino positioned on a cutting block. This is simply a baseboard (**a**) onto which two sides forming a corner (**b**) are firmly nailed. Before beginning, gently warm the block on a radiator so that it is slightly softened and easier to cut. If right-handed, ensure the light falls from the left. Keep the cutting edge constantly in view and remember three basic rules: always cut away from your body; always have your two hands behind the cutting edges of tools; do not cut too deeply. Low areas can be cleaned out afterwards. Begin by cutting the basic elements with a V-shaped tool. Then remove larger areas and finally cut the smaller areas with a knife or appropriate fine tool.

Tool marks

Each tool produces a different mark. A gouge (**1**) produces a scooped line. V-shaped tools (**2**) produce a line with varying thickness. A fine tool (**3**) is good for stippled and cross-hatched areas and a knife (**4**) produces clean edges.

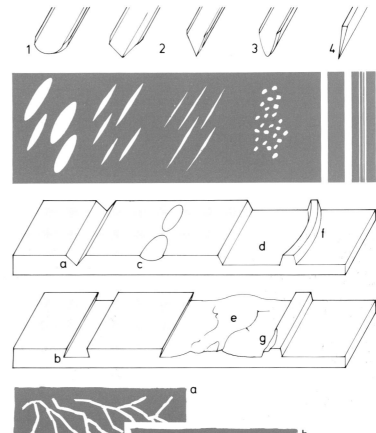

Types of cut

When cutting with a knife, ensure the edges slope away from the dark areas (**a**) and do not undercut the sides (**b**). Gouges are best used for cutting scooped marks (**c**). Ensure the large white areas (**d**) are free of irregular raised areas (**e**) which could hold ink when printing. Individual black lines must have supportive sides (**f**) and must not be damaged (**g**) by clearing out the larger areas.

Progressing a print

Begin with outlining the basic design using a small V gouge (**a**). Then clean out the main areas (**b**) with a large U-shaped gouge. Work into the block with knives and small gouges to create the detail (**c**). Constantly resharpen your tools so that you have no difficulty in obtaining clean-cut edges.

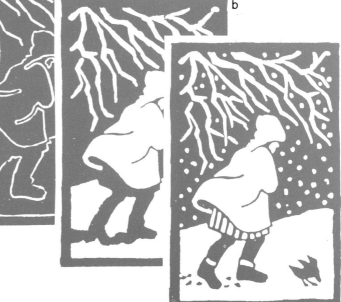

55

linocuts: inking and printing

Lino blocks may be inked using water-based inks and paints, or oil-based inks. To ensure a greaseless surface, rub with a dilute solution of ammonia. The ink is applied with a brush, dabber or roller. Care must always be taken to prevent the ink touching the lower areas of the block. Printing the block always requires clean hands and a method of holding the paper firmly and constantly in the same position. Paper is placed over the inked block and pressure is applied to the back of the proofing paper by a burnisher, clean roller or printing press. During burnishing, you may lift a corner of the paper to examine the quality of the impression.

Mixing the ink
When applying the ink by roller or dabber, you must prepare a sufficient quantity for your present needs. Mix the ink on a clean, smooth piece of glass or plastic sheet. The ink must be evenly spread to ensure that, when transferred to the block, there are no thick or thin patches.

Inking with a roller
Polyurethane or rubber rollers are used to ink the block. Polyurethane must not be washed in water. Any imperfections in the roller's surface will result in inkless areas appearing on the block. All ink must be thin and evenly distributed. Roll the roller frequently over the inking plate and the block, varying the direction with each roll to ensure an even distribution of ink. Rollers should be stored with the stock, i.e. the barrel that carries ink, free from contact with any surface. This is essential with soft rollers.

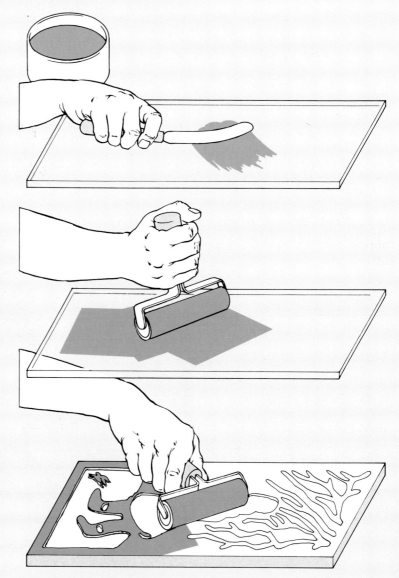

56

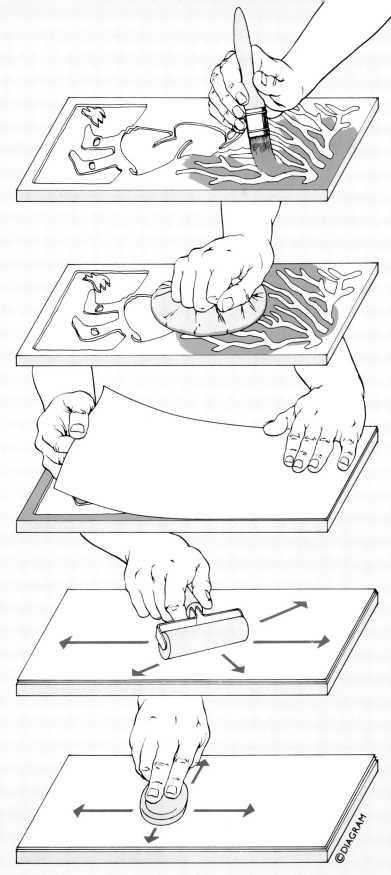

Inking with brushes

Brush inking is useful to achieve gradations of colour on the block, or two different colours on two different areas. Brushing must not permit ink to remain in the lowered areas of the block. Brushing works best with large areas requiring uneven colour. Fine line work can be badly smudged by inept brush inking.

Inking with a dabber

Great care must be taken over the amount and consistency of the ink on the dabber, and the firmness of the dabber's surface.

Printing

Printing is usually done on thin, smooth, soft papers. Hard papers fail to absorb the inks and also do not respond well to the back pressure of the roller or burnisher. Always work the pressure away from the centre area to the edge, and always ensure that the paper retains its original position on the block.

Roller printing

This method requires an additional roller to the one used for inking. It is best for large areas but poor for fine areas with large exposed areas of the block not containing ink.

Burnishing printing

This method is very good for maintaining control over the intensity of printing. Wooden spoons, which are easily available and cheap, can be used.

57

linocuts: reduction method

The reduction method of colour printing is the simple process of cutting away the block, printing in a colour, cutting more from the same block, then overprinting, and continuing in as many colours as you wish. The method requires you to think through your design before starting, and printing from the first stage as many proofs as you require as you cannot reprint the original image after the block has been recut.

Colour effects
Greatly reduced two-colour design (right). The overprinting of the first proofing creates very strong colour.

Developing a design
The three proofs (below) show the stages of a reduction block. First cutting (**1**), second cutting (**2**), overprinting of the second stage onto the first (**3**).

1

2

Progressing a print

Having transferred down the design in the usual way establish the drawing with waterproof ink. Waterproof felt tipped pens are excellent for drawing up blocks. First cut away areas which are to appear white (**1**), ink (**2**), and print (**3**). Ensure that you have enough copies of this proofing for the total edition. Clean the block (the waterproof ink should not wash off), then begin again the process of cutting, inking and proofing. If you make sure that the paper is replaced at each proofing stage in exactly the same position, then the register will be correct.

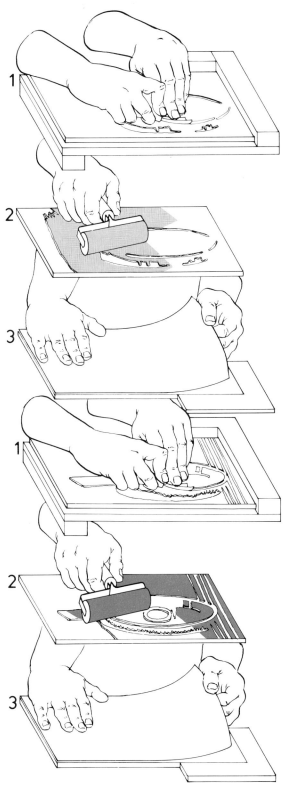

linocuts: etched lino

An etched lino block requires very great care to avoid accidents during the production. Always work within close proximity of running water and in a well-ventilated area. Wear protective gloves, apron and goggles at all times. Always clean up thoroughly after each session of production. Store caustic solution and crystals appropriately.

Qualities
Because the image is drawn with a brush and the shallow areas are irregularly bitten by the acid, the resulting qualities are much freer than in a normal linocut. Additional details can be added with conventional cutting tools. The design (*above right*, reduced; detail *above*, actual size) has strong emotional qualities and the second colour was added with a lino block conventionally produced.

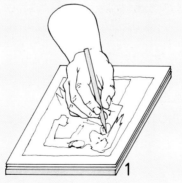

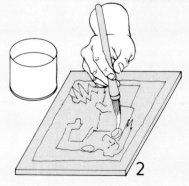

The process
Caution is the most important feature of production. Always be safe rather than sorry. Always clean up after yourself and always have water on hand to dilute the caustic solution.
1 Sketch out or transfer down the design as with normal linocuts.
2 Paint the elements which will appear black in the printing, using a brush or swab with a warm solution of wax.
3 Place the block in a shallow photographic tray (**a**). Use a nylon paint brush (**b**) to apply a diluted solution of caustic soda (**c**) to

Making a resist varnish

If artists' etching varnish is not available, then a thinned solution of paraffin wax can be used. Never melt wax over an open flame or electric ring.

1 Place wax in a clean tin can.

2 Stand in a metal or plastic bowl.

3 Pour boiling water into the bowl. When wax cools and hardens, replace cooled water with more hot water.

Making a dabber

Acid and wax are applied with nylon haired brushes (**A**) or swabs (**B**) made from an old sponge, cottonwool or cloth tied to a shaft. Both can be washed in turpentine, then in a solution of hot soapy water, if used for wax. Wash in water if used for caustic solutions. If left to dry, they harden and become unusable.

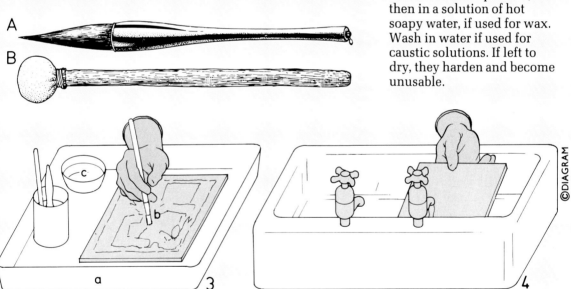

the areas to appear white. Further drawing can be done with the acid, ensuring you keep the acid constantly working over the surface. Varying depths and textures can be achieved by changing the solution's strength or the length of time the caustic solution is left on the block.

4. Wash the block in running water and wash the tray and tools after use. Strong caustic soda can cause severe burns so use in accordance with the manufacturer's instructions.

5 Print the block in the normal manner and add details by cutting or by additional colour blocks.

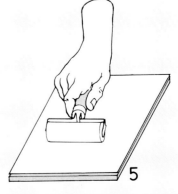

linocuts: register

The register of a series of colour blocks is vital to ensure the same position of the paper in each subsequent proofing. There are a number of methods but all require you to take care in placing the block or paper down against pre-made guidelines.

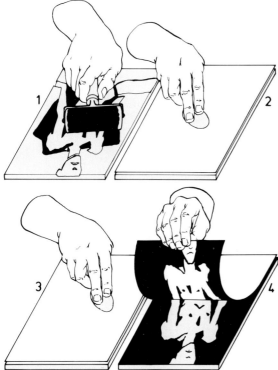

Transfer technique
After making your first block (**1**) and proofing it (**2**) several times, you can print these still damp proofs (**3**) onto new clean blocks. These images (**4**) will be a useful guide in progressing the cutting of subsequent blocks as the positions of earlier elements will be apparent.

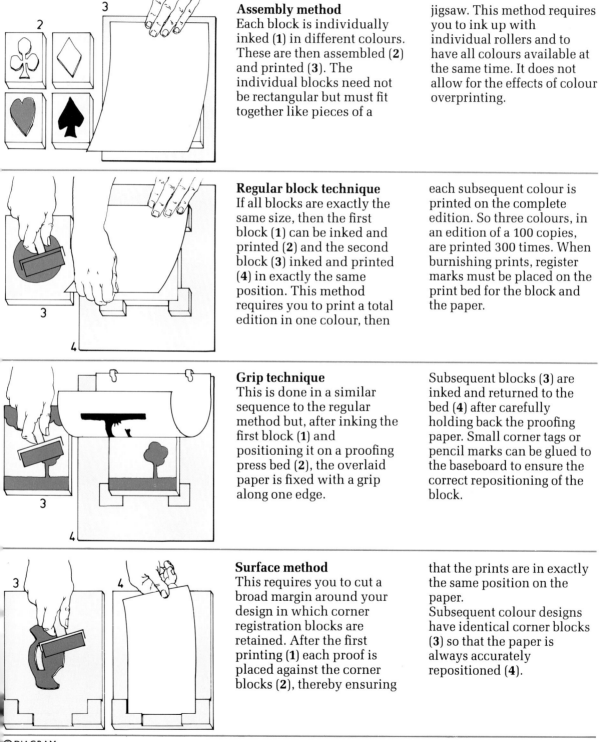

Assembly method

Each block is individually inked (**1**) in different colours. These are then assembled (**2**) and printed (**3**). The individual blocks need not be rectangular but must fit together like pieces of a jigsaw. This method requires you to ink up with individual rollers and to have all colours available at the same time. It does not allow for the effects of colour overprinting.

Regular block technique

If all blocks are exactly the same size, then the first block (**1**) can be inked and printed (**2**) and the second block (**3**) inked and printed (**4**) in exactly the same position. This method requires you to print a total edition in one colour, then each subsequent colour is printed on the complete edition. So three colours, in an edition of a 100 copies, are printed 300 times. When burnishing prints, register marks must be placed on the print bed for the block and the paper.

Grip technique

This is done in a similar sequence to the regular method but, after inking the first block (**1**) and positioning it on a proofing press bed (**2**), the overlaid paper is fixed with a grip along one edge. Subsequent blocks (**3**) are inked and returned to the bed (**4**) after carefully holding back the proofing paper. Small corner tags or pencil marks can be glued to the baseboard to ensure the correct repositioning of the block.

Surface method

This requires you to cut a broad margin around your design in which corner registration blocks are retained. After the first printing (**1**) each proof is placed against the corner blocks (**2**), thereby ensuring that the prints are in exactly the same position on the paper.
Subsequent colour designs have identical corner blocks (**3**) so that the paper is always accurately repositioned (**4**).

linocuts: overprinting

In colour printing, the combinations of line, tone, colour, texture and shape increase with each additional colour printed. To obtain the best results from overprinting, it is essential that the colours are translucent and thinly printed. The translucence of any colour can be modified by the addition of a tinting medium to the basic colour.

Colour combinations
Each additional translucent colour printed results in other colours being produced in the print. Two printings can give three colours. Three printings can give seven colours. Too many colours in a print will result in muddy, closely-toned colour changes. Try to achieve the result required using as few colours as possible. As a general rule, print lightest colours first and darkest last.

A	B	C	D	A B C D
	A B	B C	C D	A B C
		A C	B D	A B D
			A D	A C D
				B C D

Block features
When progressing a series of blocks, try to follow some simple rules.
1 A light colour (e.g. yellow) can have large simple areas.
2 An additional light colour can overprint large areas. A blue block, for example, would turn the grass and

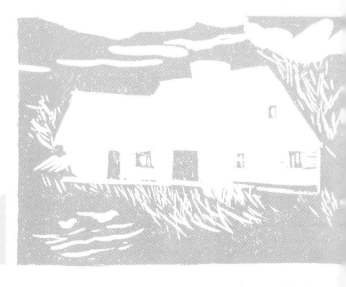

trees green on the
overprinted yellow areas.
3 Darker colours should be
kept to small areas to avoid
obliterating the earlier

effects. The strongest,
darkest colour (black) is
used to hold and describe all
the small features.

Combination effects
This book is printed in only
two colours so it is not
possible to show the full
effect of the design (*above*,
actual size) printed from
four blocks (*below*).

Experimental relief

Printing by relief process offers a number of additional possibilities: inking individual parts of the block, or separate small blocks which are combined in proofing; printing on different papers; adding colour by hand or by tissue papers; or experimenting with additives to the block which produce interesting textures.

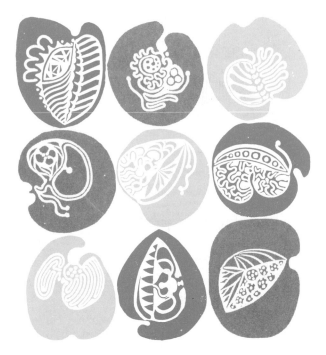

Individual blocks
The print (*right*, reduced) is the result of inking each image separately in differing colours and combining the blocks before printing to produce a range of values or different arrangement of units.

Paper possibilities
The detail (*right*, actual size) of a Japanese woodcut was printed on a special textured paper. Its character complements the print quality.

Adding colours
The print (*above*, reduced) was made by drawing with a quick hard-drying substance on plastic laminate, then printing by normal methods. The effect is improved by hand-colouring the print.

Adhesives
The experimental proof (*below*, reduced) shows the application and manipulation of a quick hard-drying substance on the block surface. Detail (*below right*, actual size) shows a possible interesting texture achieved by this process.

Paper collage
The print (*above*, reduced) was made by sticking a range of different textured materials to the surface mounting card and printing it. Tissue papers were pasted over the print to create colour areas. Overlays of translucent colours can be printed onto the image as well by cutting smooth card to the appropriate size.

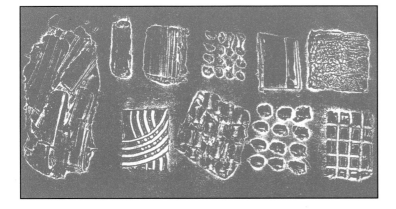

experimental relief

Card cuts offer opportunities to explore cheap and efficient techniques but the blocks are not good for very large print runs. Unlike linocuts, they have irregularities in height and surface which hold ink to different degrees; the highest printing black and the lowest light grey. A variety of texture and tone can be created and may be printed intaglio or relief. Adding materials to the surface extends the textural range.

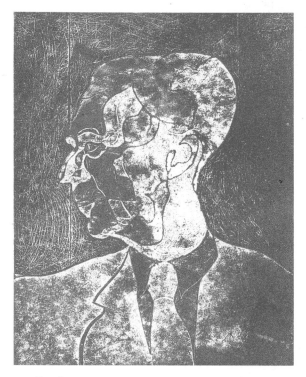

Card cutaway
The design (*above*, reduced), printed relief, shows how successful this technique can be. The detail (*right*, actual size) has fine white lines (**a**) cut into the surface; coarse textures (**b**) produced by scoring the card surface, and varying tones (**c**) produced from the different heights of the layers.

2

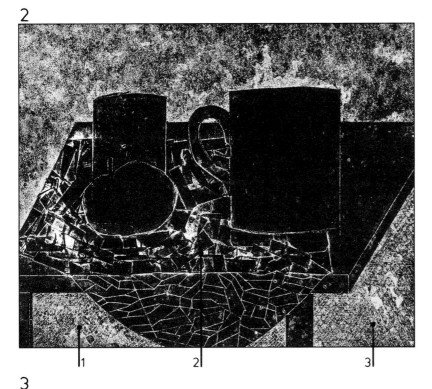

1 2 3

Additives

The design (*left,* reduced)
has three additional
elements to the one on the
facing page.
1 Large areas of the surface
were removed so that the
softer under-surface could
be inked to produce texture.
2 Adhesive tape was added
to areas to produce a mosaic-
like effect.
3 The final print was hand-
coloured to enhance the
design elements.

3

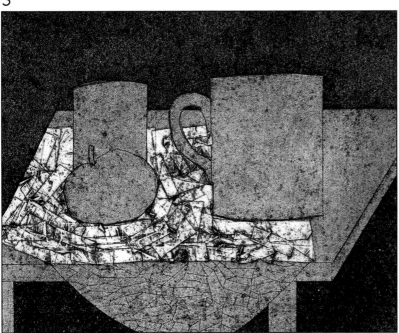

Exploring techniques

The same block printed by
intaglio method (*left,*
reduced). This technique
does not necessarily produce
a negative version as
the same surfaces respond to
the ink in differing ways.
Compare the two details
(actual size) to understand
the possibilities of intaglio,
relief printings.

Woodcuts

Woodcuts are made on the side of a plank of wood, working with the grain parallel to the surface. They can achieve greater detail than linocuts if evenly-grained wood such as cherry or pear are used, but require care in cutting as the hardness and softness of the grain offers irregular resistance to a knife. Woodcuts retain their detail for a larger edition of proofs than a linocut.

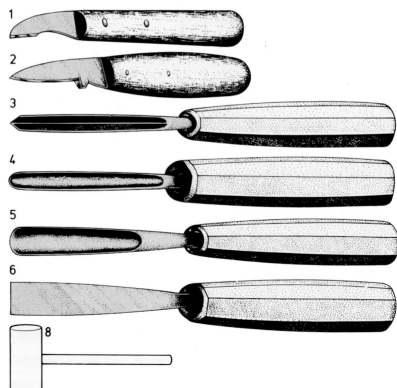

Origins
The page from a 16th-century herbal (*right*, *reduced*) shows a combination of woodcut and type. Woodcutters developed skills in detail to match the fineness of letterforms. The detail (*right*, *actual size*) shows how carefully the black lines have been retained.

Tools
Cutting tools (**1**, **2**), held like pens, must be kept constantly sharp. Gouging tools (**3**, **4**, **5**), in varying shapes, are used for cutting lines and clearing areas. A chisel (**6**) is used to level the larger white areas; a frame (**7**), in which the block is held during cutting; and a mallet (**8**), used with gouges and chisels.

Preparing the block

1 Use a power sander on rough boards, or boards containing scratches or dents.
2 Lightly sandpaper the surface to ensure an even flatness.
3 To enhance the grain quality in prints, run a wire brush over the surface in the direction of the grain.

Transferring down the design

There are three methods:
1 Draw directly onto the block, which has been painted with white gouache.
2 Place carbon paper (**a**) on the block, your drawing (**b**), then tracing paper (**c**) and firmly draw in the main elements.
3 Paste the drawing onto the surface and cut away the white areas.

Cutting the block

1 Hold the knife with the forefinger along the top of the blade to apply downward pressure and use the other fingers as guides.
2 Use a gouge by gently tapping with a mallet, ensuring that the point of the tool is always pointing away from your body.

Inking and printing

1 Ink the block as for linocuts (pp 56–7).
2 Place paper onto the block.
3 Print by burnishing. (You can also use a roller or press.)

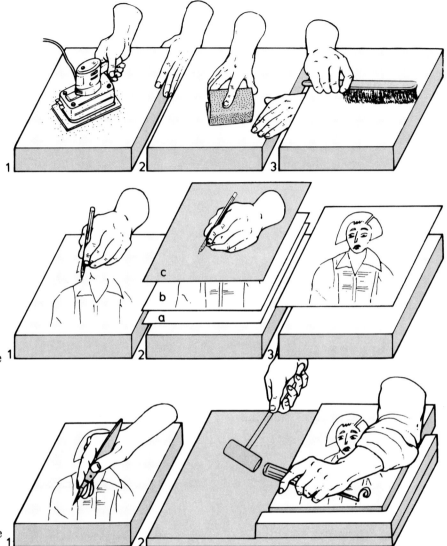

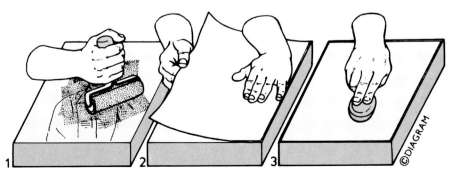

woodcuts

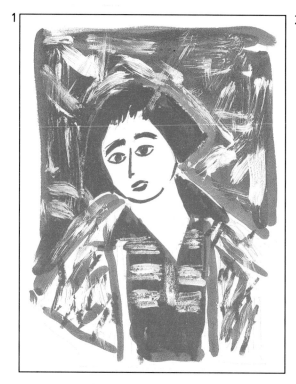

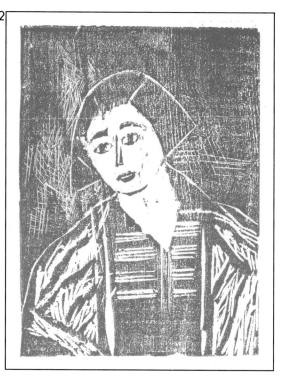

Progressing the block

A series of proofs (reduced) showing the development of the design.

1 An ink and white gouache painted sketch.

2 The basic elements cut from the wood block and lightly inked and proofed.

3 A proof with white paint added to the background to explore developments.

4 Further cutting of the background.

5 A proof on brown craft paper.

6 A proof onto which pieces of thin tissue paper have been laid to add colour and resolve the tonal effects.

Inking

Inking wood block can greatly change the effects of the drawing. The detail of **2** (*right*, actual size) has been lightly inked and shows the qualities of the wood grain. The detail of **4** (*below right*, actual size) was inked heavily and prints solid black.

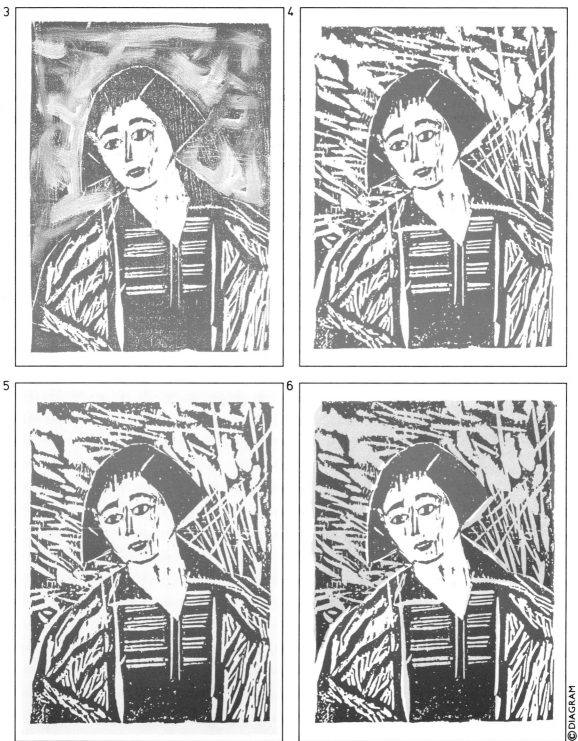

Wood engraving

Cutting into the endgrain of a block of hardwood offers greater opportunities for detail than woodcuts or linocuts. The prepolished hard surface retains very fine details and, with practice, the use of the various tools creates special qualities of fine tone and texture.

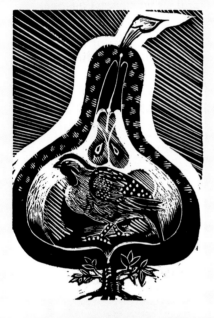

Wood engraving textures
The proof (*above*, actual size) illustrates very clearly the opportunities for strong blacks and varying greys and textures. The detail (*right*, enlarged) shows the marks of different tools to achieve this effect.

Engraving blocks
Wood engraving blocks are usually produced from pear, holly, cherry or apple wood. These trees produce fine-grained hardwoods, which are available from art suppliers with prepolished surfaces.

Block sizes
Normally not in excess of 4″×4″ (10cm×10cm). Larger blocks are achieved by joining together pieces and levelling the surface.

Bought blocks
Usually supplied with two surfaces polished for use. Protect the undersurface with a glued-on card so that it may be available for later use. Blocks can be resurfaced by the suppliers. The resulting reduction in height can be made good with card or paper backing if required.

Synthetic blocks
Materials such as perspex and heavy-gauge PVC sheet can be used. These have a poorer surface for working and must be raised by mounting on blockboard (**a**) or laminating several sheets of cardboard (**b**). These materials do not take the tools so smoothly and often have problems of surface imperfections, such as scratches or rough areas.

Tools
The lines are cut with different shaped tools. These are pushed across the surface of the wood. The angle at which the face of the tools is ground gives a sharp cutting tip to the different shaped blades.

Sandbag (*below*)
A pad made of leather onto which the block is placed to enable you to move it freely while cutting the block.

Burins lozenge-sectioned, used for fine line work, unsuitable for achieving large areas of white, offering a variable line thickness.

Spitsticker bevel-sided with a pointed base, used for curves and variable thickness lines.

Tint tool flat-sided, round-based, used for constant thickness lines when creating tones by cross-cutting.

Multiple tool numerous grooves on the base serve to produce a series of parallel lines with each cut.

Scorpers round or square-based for removing large areas of large textures.

Chisels used for levelling the floor of the white areas.

©DIAGRAM

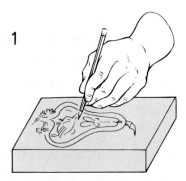

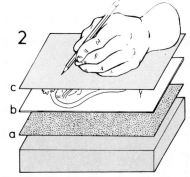

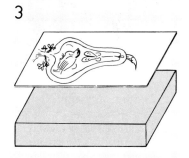

Preparing the block
Three methods can be used.
1 Drawing directly onto the block: draw with a soft pencil onto a surface pre-painted with white emulsion, or paint with indian ink the main features of the design.

2 Tracing down: place carbon paper (**a**) face down on the block, then your drawing (**b**), then a protective sheet of tracing paper (**c**). Using a hard pencil, trace the main outlines of the design.

3 Pasting down the original drawing: if the drawing is on thin paper, paste it directly onto the surface, and cut away the white areas. Wash the block free of all surviving paper before printing.

wood engraving

Cutting the block

Hold the block in your free hand (**a**) and resting on the sandbag (**b**) cut the lines with the burin held in the hand normally used for holding a pen (**c**). Carefully cut the basic elements of the design with shallow lines. To obtain curves, turn the block towards the burin, not the burin towards the block.

Holding the burin

As lines are the result of a gentle pushing action, the tool must be held firmly and confidently to ensure maximum control. Hold the shaft with the four fingers (**d**) and guide the point with your thumb (**e**).

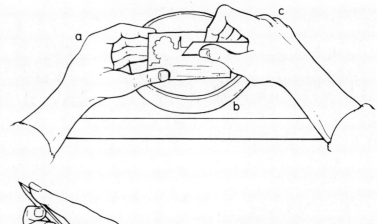

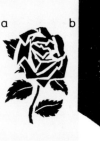

Working the block

Lines may be cut away (**a**) in strong broad lines or they may describe the details in fine careful cuts (**b**). Both proof blocks (*above*) are actual size.

1

1

2

©DIAGRAM

Advancing the block (*above*)
The block (**1**) has the initial
elements of the design cut
out and some of the detail
began to be resolved. The
proof (**2**) has the completed
and final version of the
drawing.

2

Developing the block
During cutting, a proof can
be taken (**1**) (*far left*, actual
size) and, if areas appear
dominant, then other proofs
can be made masking or
cutting away the proof to
enable you to judge the effect
of changes to the overall
design (**2**). This method
explores the effects prior to
working up the design.

Oriental woodcuts

The art of woodcutting originated in the Orient, and the artists developed exceptional skills in cutting and printing drawings. The tools and materials are not usually available in the West so these pages describe how the Oriental artist achieved his results.

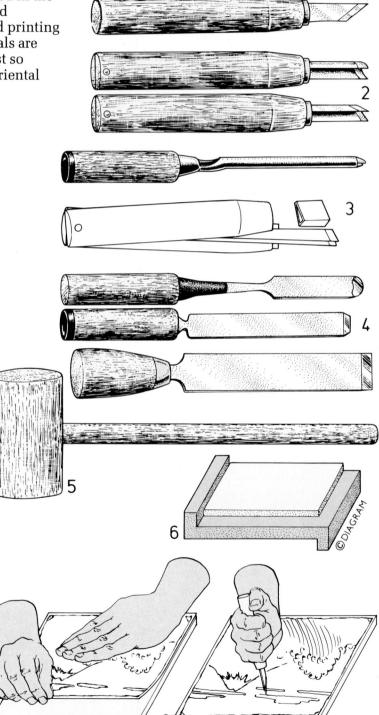

Cutting tools
1 The knife (the kiridashi or hangito) is the main cutting implement, always with an extremely sharp edge and held like a dagger, not as we hold a pen.
2 Gouges (sankaku-nomi); a wide variety of gouges hit with a mallet.
3 A simple diagram showing how the blade is replaced after removal for frequent sharpening.
4 Chisels, similar to European ones.
5 Mallet.
6 Bench hook, used in the same way as a European workblock.

Cutting the block
Very similar to European woodcuts.
1 Most frequently the Japanese pasted down the design and then cut away the white areas of the drawing.
2 Basic design elements were cut first with a knife.
3 Main white areas were removed with gouges.
4 Fine detail was worked into the black areas with knives.

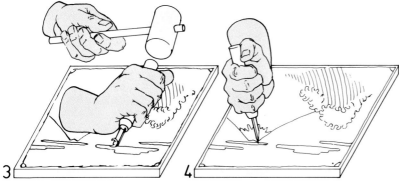

The main use of the woodcuts was for book illustrations or theatre bills. Always the text was included with the drawings to form one woodblock surface. This allowed the design to combine the text and the drawings into one single image. The drawing (*above, actual size*) is from an early 19th-century book.

oriental woodcuts

Inking tools

All Japanese blocks were inked by brush or dabber. Rollers were never used.

1 Three varying widths of brush.

2 Dabber similar to European ones.

3 Burnishers; either round, made of bamboo fibres (**a**) or blocked and made of reeds (**b**).

Paper

Japanese prints were usually made on fine rice paper which did not allow printing on the reverse side. The early 19th-century print (*right*, reduced) shows some interesting features: it is a left hand page of a book and the chapter title and page numbers show on the left; it is an illustration of a page from a book which shows the binding technique of cord lacing; it illustrates a popular theme – actors, one of whom is admiring his theatre poster printed by woodcut; the other is in the theatre costume of a woman.

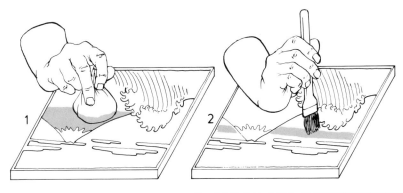

Inking and printing

Blocks were dabbed (**1**) or brushed (**2**). Both methods required great skill to avoid the ink entering the lowered areas. Very frequently the block had differing areas inked in two or more colours. The block was then burnished.

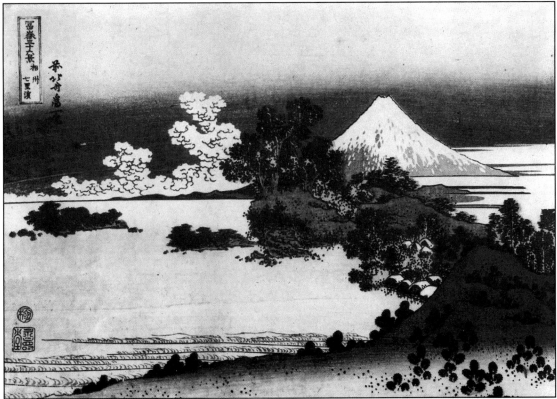

Coloured blocks

The Japanese excelled in achieving a wide variety of tonal effects from a minimum of printings. This was very often the result of wiping colours across the block. Hokusai's landscape (*above*, reduced), with detail (*left*), shows the gradations possible.

Part Three

STUDIO TECHNIQUES

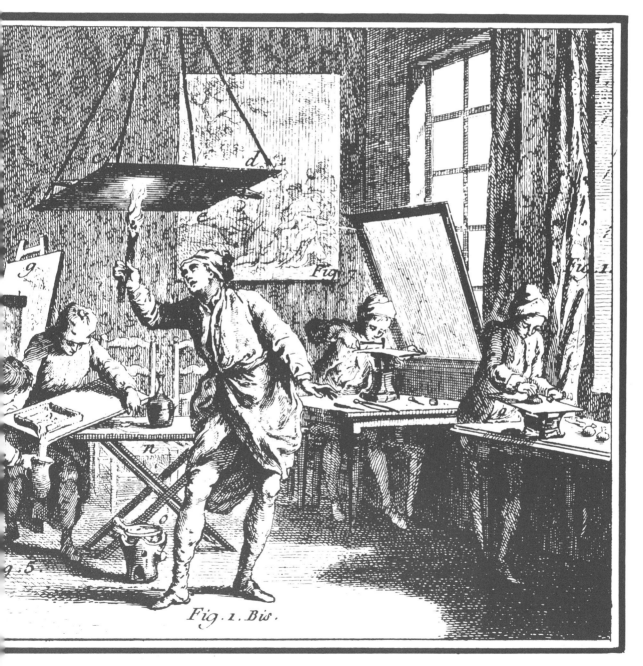

Fig. 1. Bis.

Intaglio process

The intaglio process is one in which the ink is transferred onto the paper from an incision in the surface of the printing plate. The method requires specialist studio facilities.

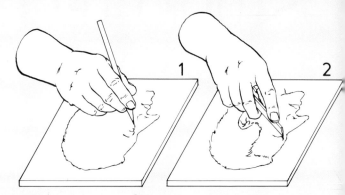

Methods of intaglio
The examples of six methods of producing an intaglio print are reproduced actual size.

The basic process
1 The design is transferred onto the plate by either tracing down through paper or drawing directly onto the plate.
2 The lines are either cut into the surface (drypoint or engraving) or bitten by acid (etching).

Drypoint
The scratching into the surface with a heavy, steel point. The resulting line has a raised metal edge (burr) which retains ink. This method is not suitable for large print runs.

Engraving
The cutting into the surface with a burin, a tool with an extremely sharp point which removes a V-shaped groove of varying widths and depths.

Etching
The scratching through a protective wax layer with a needle and establishing the permanence of lines by biting into the plate with acid. Variations in line are achieved by varying the time that different parts of the drawing are exposed to acid. Deeply bitten lines print black, shallow print grey.

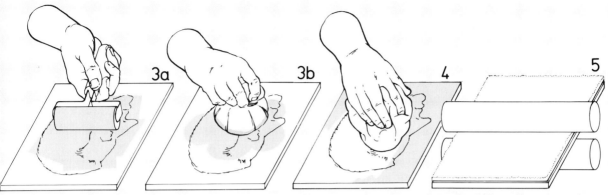

3 The plate is inked all over, either with a roller (**3a**) or a dabber (**3b**), ensuring that the ink is forced into the grooves. Card is also used to scrape ink across.

4 Excess ink is removed by wiping the plate surface clean.

5 A sheet of damp proofing paper is then, under heavy pressure, pressed onto the plate drawing the ink from the grooves and recesses to form the printed image.

©DIAGRAM

Soft ground
Drawing onto rough paper which is laid over a soft wax covering the plate. The wax, when drawn on firmly with a hard point, lifts the ground and exposes lines which are then etched. Materials with distinctive surfaces may be pressed into the ground and lifted away to create textures, etc.

Aquatint
A layer of fine resin dust is fused onto a plate surface by heat. Varnish, applied by brush, is used to protect areas, and the exposed areas of the plate bitten with acid at varying depths to produce a range of tones.

Mezzotint
The surface of the plate is evenly pitted with a multi-pointed tool (rocker). By scraping, burnishing and polishing the pitted surface to varying degrees, the plate's capacity to hold ink is more or less reduced, creating a range of tones.

intaglio prints

When examining prints, each reveals small clues as to the method of production. Intaglio prints are easiest to recognise because of their surface qualities. Remember that whatever the condition a print is in, the wisest valuation is to buy prints which you like and which give you pleasure. Buying prints as an investment requires special knowledge and can subject you to the risk of buying a fake. The examples reproduced here transform intaglio into planographic reproduction, so the features have to be described and cannot be illustrated.

The plate impression
Intaglio prints should all have a plate mark (**1**). This is the indentation caused by the edge of the plate as the surface is pressed against the paper. Unfortunately, this edge is often trimmed off, or hidden under a mount. Because intaglio prints are proofed on dampened paper, the white areas (**2**) often appear smoother than the surrounding paper surface.

Mixed techniques
Intaglio prints often contain elements of a number of processes. An etching may have drypoint elements, or engraved lines. Other areas may have soft ground work, or tints added by aquatint or mezzotint.

Identifying originals

The hardest feature to establish is whether the print is from an original plate or not. Print sellers in the 19th and early 20th century developed methods of duplication which can easily fool the uninformed. The print may be from a later impression of the plate; it may be from a duplicate plate; it may be a copy plate by a competent engraver; or the print may be from a photograph of an earlier print and reproduced by other processes such as lithography or photogravure. It is wisest not to become involved in the authenticity of a print as this requires professional expertise.

Print qualities

Details from an engraving (**1**) and an etching (**2**), both actual size. Engravings usually have tighter details and more exacting lines, etchings are freer and appear to be drawn with 'wirey' lines.

Drawing details

Very often the quality of the lines reveals the method of creation. Engravings have lines which can fluctuate from thick to thin (**1**). Etchings have lines of constant thickness, but differing strengths (**2**). Both achieve tonal effects by the criss-crossing (cross-hatching) of many fine lines.

Drypoint

The simplest method of obtaining intaglio lines is to cut into the plate surface with a sharp steel point. No surface preparations or acids are required, nor do you have to master the skills of using an engraver's burin. This direct method offers immediate printing results but has two disadvantages: all the lines have a fuzzy edge when printed and the plate impressions deteriorate with printing.

1

a

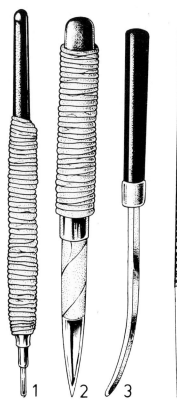

1 2 3 4 5

Tools
1 Point; a hard heavy metal scriber, kept sharp.
2 Scraper; a triangular-bladed tool for removing fine layers from the plate surface.
3 Burnisher; for rubbing down areas of the plate.

Making a point
Cut or snap 6″ (15cm) from a ¼″ (5mm) metal round file (**4**). Sharpen the tang (the part which is held in the file's handle) to a fine point. Bind the file's surface with tape to give a comfortable grip (**5**).

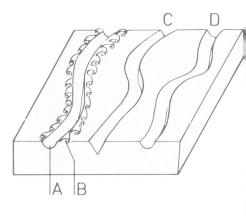

2

b

Line quality (*left*)
Cutting into copper, zinc, aluminium or plastic with a steel point produces a groove (**A**) and a burr (**B**), both of which retain ink. Engravings (**C**) and etchings (**D**) only retain ink in the hollows, so produce cleaner lines.

Working the plate
First lightly scratch the main elements of your design. Then build up the tones with strong strokes. During drawing, rub the surface lightly with an inked rag so that the lines are revealed. Hold the point at an angle to the surface so that it cuts the metal, leaving a ploughed furrow with raised sides. Ink and print as for intaglio plates, but apply less

pressure to retain the raised edges of the lines.

Drypoint results
The examples (*above*) are reproduced actual size. The first proof (**1**) shows heavy working of lines (**a**). The later proof (**2**) shows burnished and scraped down areas (**b**).

drypoint

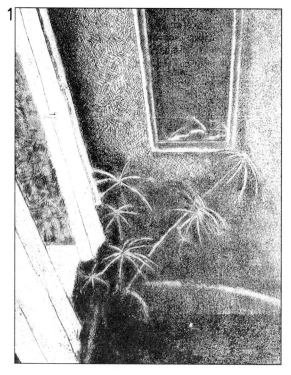

Progressing a print
Drypoint offers you the
opportunity to enhance the
state of an etching or
engraving quickly. Each
impression of the plate can
be altered by the simple
method of scratching
directly onto the plate. The
print of a room (*above*)
shows the progression of
drawing. These examples are
greatly reduced so do not
show the surface qualities.
1 An etching with
additional drypoint
drawing.
2 Second impression shows
the curtains scraped out. The
very dark areas are the result
of overinking.
3 Final proof, with the
curtains redrawn by
drypoint.

Drawing details
Drypoint, when handled
with delicacy, can produce
very fine details. The 16th-
century artist Albrecht Dürer
worked this drawing (*far
right*, actual size) directly
onto the plate. He only
produced three drypoints as
he was concerned with the
loss of quality in later proofs.
Working in such detail
requires very careful
printing.

Surface qualities
Good hand-made papers are
used for intaglio works to
obtain the best range of line,
tone, etc., in the print. The
colour drypoint (*right*, actual
size) was enhanced by
adding washes of
watercolour.

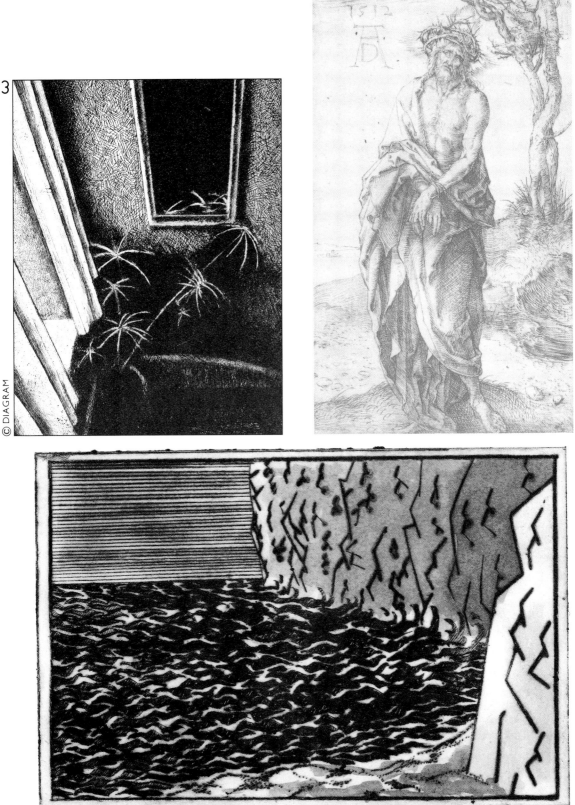

Engraving

Engraving is a method of cutting directly into the surface of a metal plate. Lines can be cut. Tones are made by cross-hatched lines or stippled dots. In drypoint and etching, lines are produced by holding the tool in a similar manner to a pen or pencil. In engraving, the lines are produced by *pushing* the tool across the surface, which results in drawings of tauter character.

Materials

Engravings are cut into a smooth polished metal surface, usually steel, copper, zinc or aluminium. Care must be taken to avoid scratching the surface. Before printing, ensure that the edges of the plate are smooth, and any roughness of surface resulting from cutting has been removed.

Tools

1 Burin or graver, the cutting tool.
2 Scraper for removing burr or erasing large areas.
3 Engraving needle, with cap to protect the point, for drawing out the basic design.
4 Burnisher for smoothing the surface of the plate after scraping. Use with a drop of lubricating oil to ensure smooth rubbing action.
5 Engraver's sandbag for positioning the plate during engraving.
6 Oilstone and can for sharpening the burin.
7 Mirror for viewing the original drawing in reverse.

Preparing the plate

Begin by tracing the main elements of your design onto tracing paper. Reverse the paper and copy it down through carbon paper onto the plate. Lightly score the design on the plate with an engraving needle. Rub printing ink into the marks to emphasise their presence and begin engraving.

Working the plate

The plate is placed over a leather sandbag (**1**) and held firmly in position with the left hand (**2**), if you are right-handed. During cutting, the depth of line can be varied by rocking the plate (**3**) to achieve very slight changes in the angle of the cutting point and the plate surface. Curved lines are achieved by turning the plate slowly in the opposite direction of the curve and maintaining the forward direction of the cutting point (**4**).

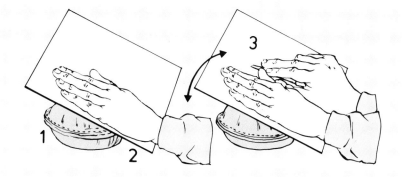

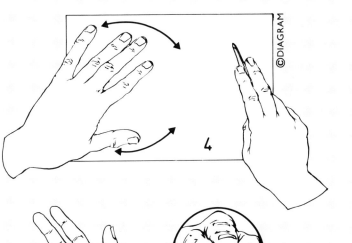

©DIAGRAM

Holding the burin

The handle of the burin is placed in the heel of the hand. The fourth and little fingers are tucked under the cap of the mushroom handle (**5**). The thumb, index and third fingers extend forward along the shaft to enclose the triangle formed by the upper half of the square-sectioned blade (**6**).

Cutting lines

Lines are cut by holding the shaft close to, and almost parallel with, the plate surface (**7**), and gently pushing forwards. Remember, do not cut too deeply or too fast. Each cut line produces a fine raised edge to the groove, the burr (**8**), which is usually removed by careful use of the scraper (**9**) to produce a smooth surface (**10**).

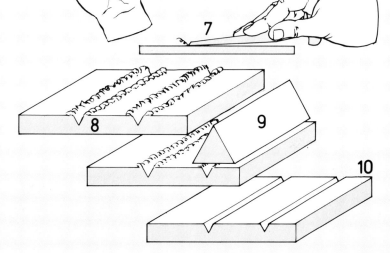

engraving

Tool marks
Three enlargements of areas of the engraving on the opposite page. Each reveals an aspect of the engraver's work.

1 Characteristic lines showing the thinning ends as the burin enters and leaves the surface.
2 Thick and thin lines resulting in deep or shallow

cuts by the burin.
3 Tones achieved by cross-cutting of many fine lines.

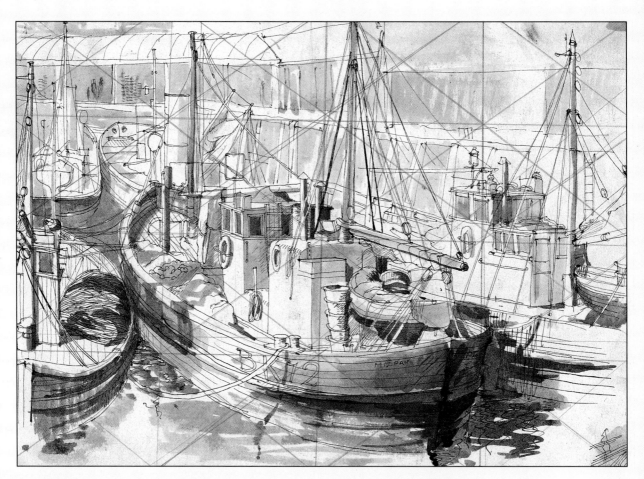

Producing a picture

Having worked out your composition, apply water-colours or inks to resolve the tonal effects. Then trace the main elements onto your plate, remembering to reverse the design. When you begin to cut the design, consult your first sketch by viewing it in a mirror. At various stages rub printing ink into the newly-cut lines to reveal the effects of your work and, when areas are complete, proof up the design and consider its developments. The

engraving (*below*, actual size) shows changes to the composition. Note the boat on the left.

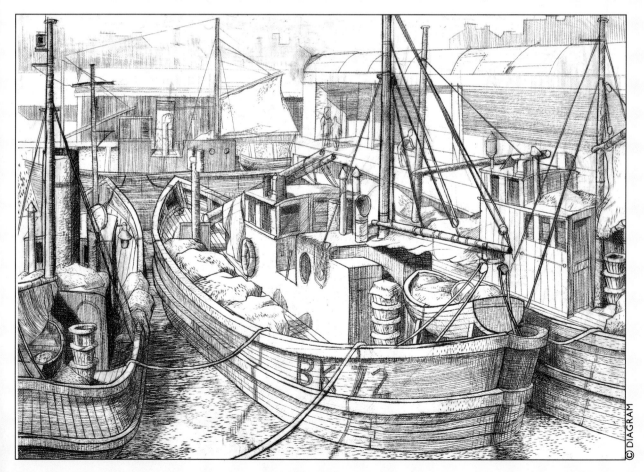

© DIAGRAM

engraving

Engraving qualities
The illustrations on these pages are reproduced by a different method from intaglio so the unique qualities can only be described and not experienced. The street scene and sheep's head are both reproduced actual size, and the Dürer engraving (*far right*) is slightly reduced.

Tonal range
The engraving of a 19th-century London street has remarkably even and subtle tones. These can only be obtained by great experience of engraving and very careful printing. The enlarged detail (*right*) shows the regular line work and the intense detail possible.

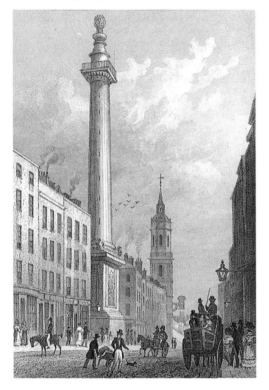

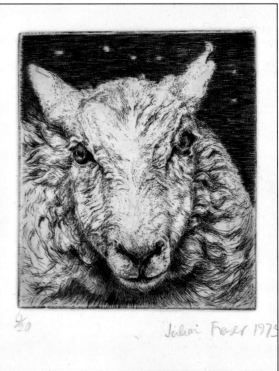

Varying the quality of line
Engraved lines may leave a rough edge on the cut, the burr. This is normally removed by careful use of a scraper or working over the plate with a burnisher. In the print (*above right*) and detail (*right*) the burr has been retained, so that during inking it, too, holds ink. The resulting print produced much richer lines and this artist has used the technique to describe beautifully the qualities of wool. A major disadvantage of this technique is that the burr wears down during subsequent printings so later proofs are less rich.

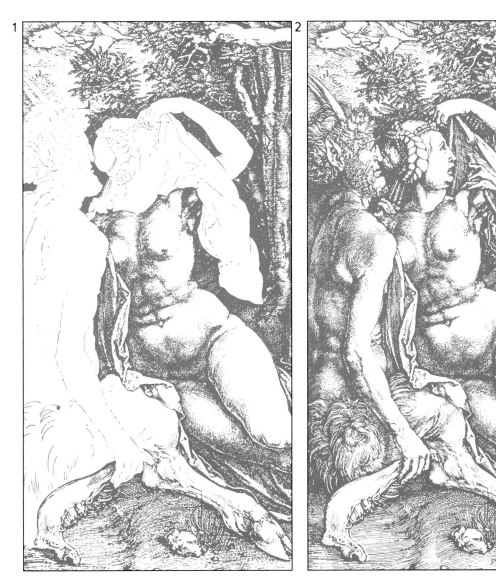

1 **2**

Developing an engraving
Two proofs made by
Albrecht Dürer in 1498
showing how he developed
an engraving. Proof **1**
shows the preliminary
engraving of the total design.
It also shows how advanced
a stage of drawing Dürer

made of sections of the
design. This method
requires the artist either to
have an exact mental picture
of all the elements, or to
have worked out on paper all
the tiny details before
beginning. For example, the
silhouette face of the figure

on the left is cut before the
facial details have been
drawn. Proof **2**, the
completed engraving, shows
how carefully Dürer had
managed to blend the overall
tonal effects of the
individually worked areas.

97

Etching

The plate surface is thinly covered with wax. Using a needle a drawing is made, scraping away the wax and exposing the metal. The plate is immersed in acid to bite the drawing into the surface. Etching in this manner is a linear process. Thick and thin lines, multiplicity of linear dot in areas in cross-hatched or stipple form, and differences in the length of time parts of the drawing are exposed to acid, create variations in tone.

The plate
Etchings are drawn on a variety of metal surfaces. It is essential that the plate is flat, has bevelled edges, and is free from grease or dirt. The table (*below*) indicates the range and suitability of the materials.

Materials (metals)	Gauge (thickness)	Suitable for	ETCHING	DRYPOINT	ENGRAVING
Zinc sheet	14 zinc wire		●	●	●
Copper sheet	18 or 20 standard wire		●	●	●
Mild steel sheet	18 or 20 standard wire		●		
Aluminium	18 or 20 standard wire			●	●
PVC sheet	thickness equivalent to above			●	●

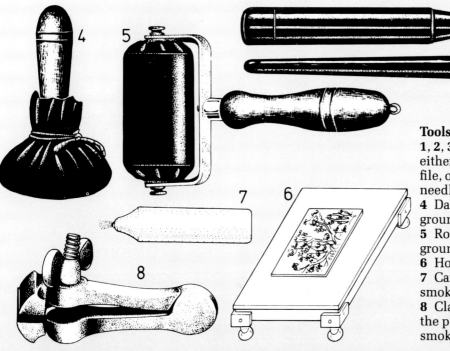

Tools for drawing
1, 2, 3 Etching needles, either home-made (**1**) from a file, or with detachable needle (**2**).
4 Dabber for spreading ground.
5 Roller for applying ground.
6 Hotplate for heating plate.
7 Candle or taper for smoking ground plate.
8 Clamp used for gripping the plate when it is being smoked.

Preparing the plate

1 Metal plates must have their edges filed or scraped to an angle of 45° to prevent the edges retaining ink or cutting into the paper when printing.

2 The surface of an etching plate must be clean and grease free to ensure an even coating of wax ground. This is achieved by rubbing the surface with a paste made of diluted ammonia and powdered whiting. The paste is washed off and the plate dried before laying the ground.

3 The plate is warmed on a hotplate and a smear of wax ground is rolled (**a**) or dabbed out (**b**) to form a thin even continuous film across the entire surface of the plate.

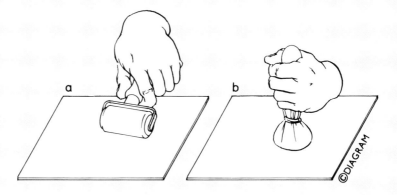

Smoking the surface

After the plate has been ground, and while still warm, the tip of a candle flame is passed over the ground surface, leaving a deposit of soot which is absorbed by the warm wax to give a black ground that contrasts strongly with the drawn lines.

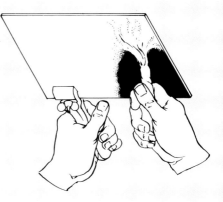

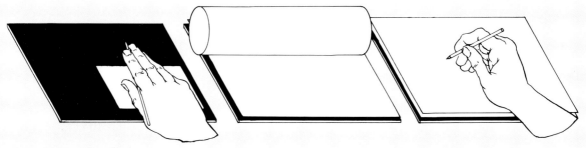

Drawing on the plate

Using an etching needle, draw through the ground using pressure firm enough to remove the wax without severely damaging the plate surface.

Transfer drawings

Place the original drawing (if drawn with a soft pencil) face down on the surface of the plate, and run through the etching press. The graphite drawing will then transfer onto the ground plate to be redrawn with a needle.

Basic design transfer

Place a sheet of coloured carbon paper and your drawing on the plate surface. Redraw the image with a firm hard point to reproduce the image in carbon on the ground plate.

etching

Biting the plate is the most hazardous part of the proceeding. It requires careful attention to safety procedures to avoid accidents. Plates are often preceded by a test plate to enable you to judge the length of time it takes the acid to bite. Plates can be bitten in stages. The longest submersion in acid produces deepest (darkest) lines. The plate may be cleaned after biting, and reground, new drawing added and rebitten.

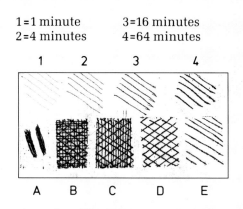

1 = 1 minute 3 = 16 minutes
2 = 4 minutes 4 = 64 minutes

Acids
All acids are dangerous and must be handled with care. The fumes are corrosive and toxic and should not be inhaled. If acid is splashed in the eye, wash eye thoroughly with cold water and at once seek medical attention. Acid can permanently damage any surface it comes into contact with. Use only in a well-ventilated room and wear protective clothing. Wash immediately any splashed on clothes or skin. When working with acid, ensure that work areas are clean and free from hazards, and wash any objects or surfaces which have been in contact with it.

Test plate
Example (actual size) of the results of biting a zinc test plate with a solution of 1 part acid and 10 parts water at varying times. Items A–E were bitten at the same length of time, items 1–4 vary as indicated in the time scale.

Tools
1 Acids and appropriate containers.
2 Water jars and immediate access to running water.
3 Bath for acids and biting plates.
4 Stop-out varnish.
5 Brush for applying varnish.
6 Feathers to remove bubble from the plate surface.
7 Eyewash bottle.

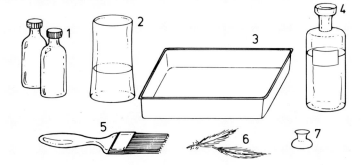

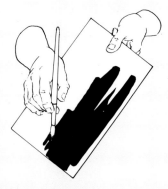

Preparing the plate (*left*)
After completing the drawing, the edges of the plate and the back must be coated with a stop-out solution to protect them from the acid. Allow the varnish to dry thoroughly before submerging the plate.

Biting the plate (*right*)
Gently lower the plate into the acid and at intervals stroke the plate surface with a feather so that the bubbles of gas which form are removed, giving a line of consistent depth.

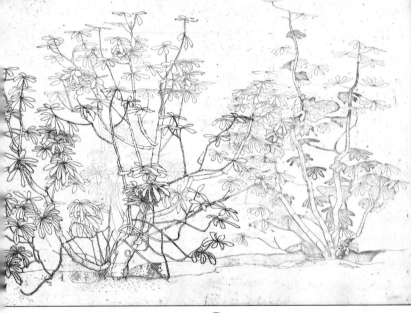

Progressing a plate

The enlarged detail (*above*) shows the three depths of bitten line.

1 Shortest period in the acid, after which it is protected with a stop-out solution.

2 The remaining parts of the drawing are etched at this stage.

3 Part of the drawing is again protected and the remainder of the drawing bitten again. Longest immersions produce deepest grooves which print darkest lines.

Plate stages.

The design (*above left* and *left*, reduced) was etched in three stages. The plate was cleaned and a fresh ground laid. The additional trees were drawn and re-etched in the second proof.

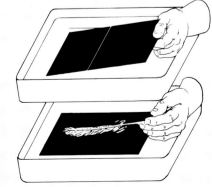

Bitten lines

Brief exposure to acid creates shallow lines (**a**). Longer exposure produces deeper lines (**b**). Excessive exposure produces wider lines of a coarse uneven quality, causing densely drawn areas to break down, leaving a saucer-shaped hollow rather than a net of lines (**c**).

Soft ground

In etching the ground is scraped from the plate exposing metal to acid. Soft ground is lifted by pressure from the plate surface either by drawing with a firm point on to grained paper placed over the plate or by impressing materials into the ground. These, when lifted away, expose the metal which is then etched.

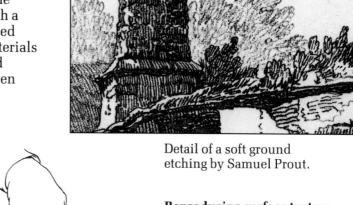

Detail of a soft ground etching by Samuel Prout.

Reproducing surface texture of materials
Objects are laid on the ground and overlaid with a protective sheet of paper. A roller passing over the paper produces pressure on the objects which, when removed, leave an impression of their forms by the removal of wax, which is then etched.

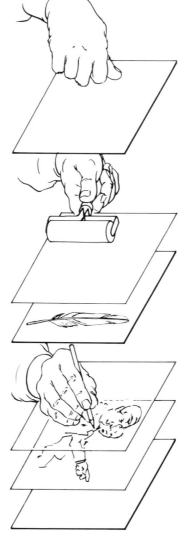

Drawing
A drawing is placed over the prepared plate, then overlaid with tracing paper. A ball point or hard pencil is used to redraw the design, and the resulting pressure lifts the ground onto the back of the drawing, exposing lines which are then etched. The tracing paper protects the original drawing from damage during redrawing. Drawings can be made direct.

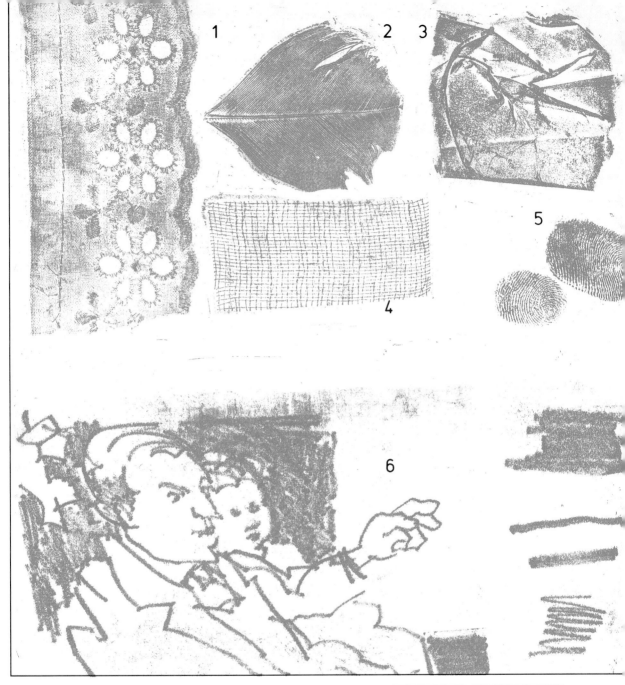

Test plate

The print (*above*, actual size) was drawn or pressed onto the plate as a test of the timings required for acid biting and the pressures required for impressions through the wax. This print was produced on zinc with a biting time of 35 minutes in a solution of 10 parts water and 1 part nitric acid.

Examples **1–4** were produced by laying the objects onto the ground and pressing the protective cover with a roller. Example **5** was by direct pressure with the fingers and **6** was by an overlaid drawing. The enlarged detail (*right*) shows the texture of the back of the paper on which the original drawing was produced.

Aquatints

Aquatints offer opportunities to add tones and textures to an etching or engraving. The plate is first covered with a fine layer of resin dust, and the differing tones achieved by protecting areas with a coat of varnish during progressive submergence in acid.

A	E
B	F
C	G
D	H

Test times
A 30 seconds
B 1 minute
C 2 minutes
D 4 minutes
E 8 minutes
F 16 minutes
G 32 minutes
H 64 minutes

Dust box (right)
A wooden box containing a revolving wire mesh table. Dust is raised and, before settling, the plate is placed into the box on the mesh to catch the particles.

Test plate
A zinc test plate (above, actual size). The changing tones were produced by leaving the plate for different lengths of time in a solution of 1 part acid and 10 parts water. Test plates ensure a predictable tonal value when working on the final aquatint.

Basic principles
Resin grain settles on the plate (**1**). After heating, grain particles melt to form protective spots (**2**). Acid bites around each grain, lowering the surface of the plate (**3**). These lower areas retain ink and produce printed image (**4**).

1 2 4

3

©DIAGRAM

Aquatint features
Details of a print reproduced actual size. The print clearly shows the variety of effects possible with aquatints.
1 Coarse ground texture produced by large particles of resin.
2 Fine ground texture produced by very small particles.
3 Irregular ground texture produced by dusting on fine resin, then 'peppering' with larger pinches of resin.
4 Lines of scraping away layers of bitten aquatint.

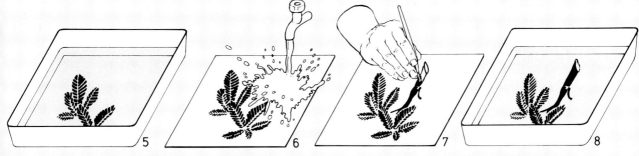

5 6 7 8

The method
First degrease the plate surface in preparation for the ground. Gently tap a shower of resin dust from a container onto the plate surface (**1**). Changes in texture are the result of holding the sprinkler closer or farther from the plate, or from using differing fineness of gauze, through which the dust is sieved. Place the plate over a slow regular heat source and keep it there until the dust particles melt (**2**). Cool the plate (**3**) and then protect the edges and back with varnish. Paint the white areas of the design onto the plate with stop-out varnish (**4**). Submerge the plate in acid and bite for a controlled time (**5**). Remove and wash the acid off the plate with cold water (**6**). Allow to dry. With stop-out varnish, protect those areas of the plate you require to be the palest grey (**7**). Repeat biting (**8**) and protecting until the full range of tones has been achieved. Remember, you cannot judge the intensity of your tones on the drawing unless you have first tried a test plate. Clean resin and varnish off the plate.

aquatints

The surface of an aquatint is pitted with tiny irregular lines which require exact proofing to obtain a satisfactory result. Here the same drawing has been produced on two separate plates to reveal some of the difficulties. Plate **A** has poor atmosphere and excessive coarse textures. Plate **B** shows two proofing results: proof **1** is overinked and poorly cleaned; proof **2** shows better values for lines and tones.

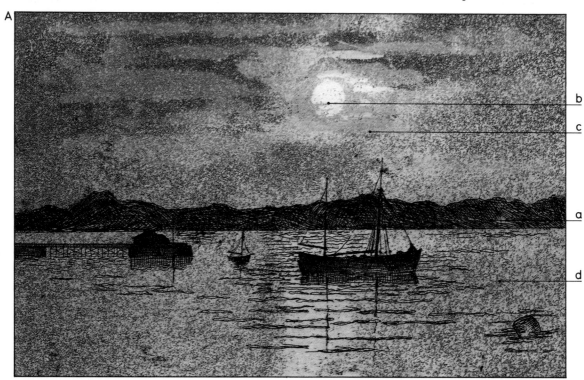

Finally, midtone areas were stopped-out and all remaining areas bitten, resulting in white areas and three tones.

Surface qualities
The prints on this page are actual size. Surface details can be more easily examined when enlarged (*left*).

Aquatint problems
Proof **1** illustrates these problems. During etching the midtone area was badly stopped-out, resulting in foul biting. During inking the plate was overinked and not thoroughly cleaned. Finally, the print is on thick heavy brown paper, resulting in a dark and obscure impression.

Plate A
The landscape was drawn and etched (**a**). Then two stages of aquatint were etched: first the white (**b**); then the midtone (**c**). The plate was then cleaned and a new tone laid and etched (**d**). This second tone is over-coarse and produces a flat and foggy impression.

Plate B
Proof **2**: the picture was redrawn and etched. Notice the different way the waves are drawn. Then tones were laid. First white areas were stopped-out and all remaining areas bitten. Next pale areas were stopped-out and all remaining areas bitten.

B¹

B²

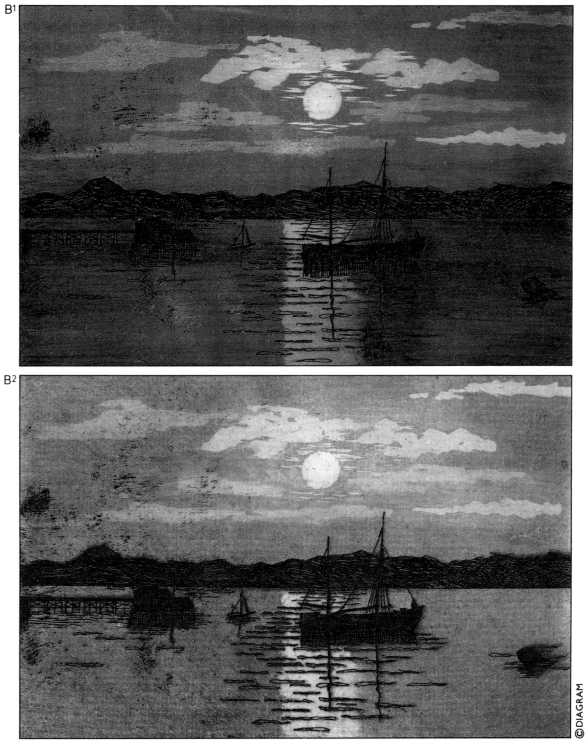

©DIAGRAM

Mezzotints

The method of drawing by mezzotint is in the reverse order to drawing by engraving in that the areas that are most worked upon produce the lightest tones. A well-ground plate would print a rich black. By working the plate with a burnisher and scraper, the capacity of the surface to hold ink is reduced. The traditional use of the technique was to produce prints which copied accurately the tonal values of paintings.

Tools
1 Rocker for laying the texture on the plate.
2 Roulette for texturing small areas and adding mezzotint areas.
3 Stippler for small areas.
4, 5 Gravers for line work. The mezzotint artist also uses the scraper and burnisher to create variety of tone.

Painters' copies
The mezzotint (*right*, reduced) by Faber, produced in 1731 from a painting by Kneller, shows the ability of the technique to copy a painting's tones. The detail (*below*, actual size) hardly reveals the pitted surface which is apparent in the greater enlargement (*bottom*).

Grounding the plate
The plate surface is pitted by rocking close, evenly spaced lines in one direction across the entire surface. This process is repeated working at right angles to the previous direction. A minimum of eight directions is necessary to obtain an evenly worked ground. The action of the rocker pitts the plate surface and raises small burrs, both of which retain ink.

Alternative methods
S. W. Hayter's engraving (*left*, reduced) has a tone produced by rubbing the surface in one direction with a coarse carborundum. The lighter areas are worked back into the drawing by burnishing.

Textures and tones: sugar-lift

Adding tones to an etching can greatly increase the richness and expressive quality of the drawing. Light, shade, texture, colour indications, reflective and absorbent surfaces can all be described with a tone. In addition to the traditional method of aquatint, other techniques can be explored such as sugar-lift aquatint, or spit-bite tones.

Sugar-lift solution
Made by the artist, the proportions are usually: 1 part sugar, 1 part water, mixed and stirred. Add 1 part gum arabic and stir well. Add 8 parts cold water. Finally, add 1 part black poster colour paint (gouache) to make the mixture visible when applied to the plate.

Progressing a plate
Four excellent examples of working design through stages of development (*below*, greatly reduced). Each stage clearly shows the application of differing techniques.
1 Design drawn and etched on plate (**a**), areas spit-bitten (**b**).

2 Sugar-lift tones (**c**) and conventional aquatint tones (**d**) added. (Detail, actual size, *right*.)
3 Extensive scraping back of plate (**e**) and new aquatints laid (**f**).
4 Areas re-scraped (**g**) and extensive drypoint work added (**h**).

Sugar-lift procedure: 1

1 The plate is prepared as for an etching.
2 Using pen or brush, make a drawing on the plate surface with sugar solution.
3 Allow drawing to dry.
4 Mix a solution of 10 parts white spirit to 1 part stop-out varnish. Apply a thin even coat to the drawn surface of the plate using a cottonwool swab or large, soft-hair brush.
5 Allow to dry, or gently heat to speed drying.
6 Submerge the plate in hand-warm water and the areas painted with sugar will dissolve, revealing the plate surface.
7 Lay an aquatint ground on the plate in the normal manner.
8 Bite in acid the first tone.
9 Wash away acid, allow to dry, but do *not* clean off ground. Repeat the procedure from stage **2** for each successive tone.

Sugar-lift procedure: 2

1 Clean and prepare the plate and lay a conventional aquatint ground on the entire surface.
2 Make your drawing using the sugar-lift solution and a brush (pens would damage the aquatint ground). Allow to dry.
3 Coat with diluted stopping-out varnish as in method **1**.
4 Dissolve sugar solution as in method **1**.
5 Bite plate as in method **1** to obtain the first pale tone.
6 Wash away acid and clean plate, removing resin ground and varnish.
7 Repeat **1** to **5** of procedure **2**, biting the plate for a longer time to give a darker tone in the newly-drawn areas. Cleaning and redrawing the plate between bites allows you to overlay tones on previously made tones and unbitten areas of the plate simultaneously. The procedure can be repeated until the range of tones required is achieved. Keep the range of tones small in number.

textures and tones: *spit-bite*

A method requiring supervision and care in the use of strong concentrations of acid. You must work in a well-ventilated area, protecting yourself with rubber gloves and goggles. This method involves working directly onto the plate with a strong acid solution (4 parts water and 1 part acid).

The method
Arrange the work area as in the diagram (*below right*).
1 Prepare the plate with an aquatint ground.
2 Delineate design using a sharp chinagraph pencil.
3 Draw tonal areas with acid applied directly onto the plate with a nylon brush or cottonwool bud.
4 Leave to bite for required depth, then remove acid by applying blotting paper to plate.
5 Place discarded pieces of blotting paper in water in tray.
6 Repeat application of acid until the required number and intensity of tones are achieved.
7 Wash plate, remove aquatint ground with methylated spirit.
8 Clean and print.
At all times take great care when using the stronger acid and ensure all materials and surfaces are cleaned after use. Store acid appropriately.
The spit-bitten etching (*above right*, actual size) shows the effect of blotting and varying the application. The detail (*right*, enlarged) shows the plate surface.

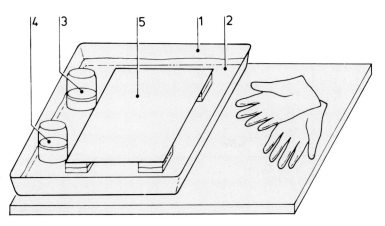

Work area
1 Tray.
2 Water at shallow level.
3 Jar of water.
4 Jar of acid.
5 Plate supported on plastic blocks.
Work in well-ventilated areas with protective gloves, goggles and apron.

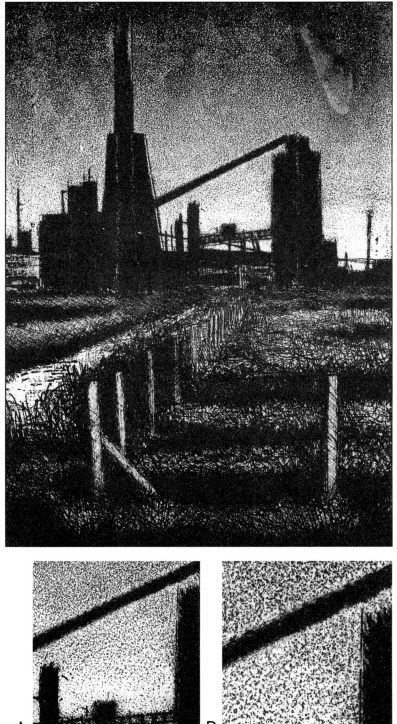

© DIAGRAM

Sandpaper technique

This method is a form of stipple engraving where the area of dots is achieved by pressing abrasive textures against the coating of hard ground and etching the resulting tiny perforations.

The method

The etching (*left*, reduced) was created by:

1 Laying a hard ground on the plate and drawing the buildings and foreground with a needle.

2 Etching the plate.

3 Washing away the acid, and running the dried plate through the press with a coarse, abrasive paper pressed to the surface.

4 Re-running the plate through the press a number of times and repositioning the abrasive each time to achieve an even distribution of dots.

5 Stopping-out the buildings and foreground, and etching the plate.

6 Cleaning the plate, then working back with a scraper to vary tones.

7 Strengthening the details by extensive drypoint work.

A

B

The detail (*far left*, actual size) (**A**) and the enlargement (**B**) show clearly the sandpaper texture and the scraping effect on the light areas.

textures and tones: experimental

The surface of intaglio plates can be modified to produce a variety of effects and textures. Plates originally intended for relief printing can be printed intaglio, or traditional techniques enhanced by textures such as marbling. Usually these prints are the result of a mixture of media such as aquatint, etching, engraving and drypoint, and the surface is often adjusted with rubbings by wet and dry abrasives. Success with these activities very much depends on the artist's ability to interpret the printed results from the plate's progress during etching.

Photoetching
The plate (*below*, actual size) was originally produced as a halftone relief printing plate. By additional work to the depth of bite, the plate was printed producing a 'negative' image (enlargement *left*). First the surface was rubbed with abrasives, then thin hard ground was laid with a roller. The unprotected areas, the hollows, were etched in the normal way and the resulting plate printed to produce a ghostly impression of the seaside.

Marbling

The design (*below*, actual size) was produced by photoetching, needle-drawing etching, aquatint and marbling. The marbling effect was added to the earlier elements by mixing a solution of water and thick polycell wall-paper paste in a shallow tray, and then pouring a small amount of stopping-out varnish onto the surface. The floating layer only is gently stirred to produce marbled effects. The plate is placed face down onto the surface, but not immersed. After carefully removing and allowing to dry, the paste is washed off in cold water. The design elements not requiring texture and the back of the plate are protected, and the plate etched in the normal manner.

The detail (*above*, greatly enlarged) reveals the variety of textures possible. Area (**a**) by aquatint and area (**b**) by marbling.

©DIAGRAM

Inking intaglio

Intaglio plates are inked while warm, so that the ink melts slightly. The plate is cooled and wiped clean. Then reheated to ensure a softening of the ink. The paper onto which the plate is printed is usually damp so that it can more easily absorb the ink from the bitten or incised image.

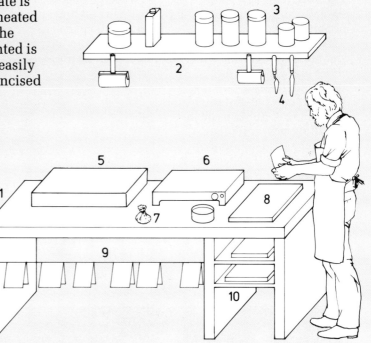

Work area
It is important that the area used for inking the plate is separate from the proofing area to ensure that no particles of ink are accidentally transferred to the paper onto which the print is made.

Equipment and tools
1 Sturdy table to carry hotplate which is very heavy.
2 Shelf on which ink, oil, grounds, dry pigments can be stored or hung.
3 Inks.
4 Palette knives.
5 Jigger box for wiping plates after inking.
6 Hotplate.
7 Dabber or spreader.
8 Slab of marble, glass or plastic laminated surface on which ink is mixed.
9 Clothes lines on which to hang tarlatan plate wipes to prevent them drying into hard lumps when loaded with ink.
10 Shelves for paper storage, tissues, newspapers, etc.

Paper preparation
Intaglio prints are printed on dampened paper. The slightly moist paper is more able to draw ink from the recesses of the plate. The paper, usually a hand-made heavy cartridge, is moistened by a short submergence in a tray of water. The dampened paper is then pressed in alternate layers of blotting paper and kept pressed between two boards under light pressure.

Printing inks
The most normal ink is one obtained in pre-mixed form, supplied in a tube. The practised printer prefers to mix an ink as a combination of copperplate oil and dry pigment. The inks may be any colour but black is most common. A useful ink for proofing is 1 part Frankfurt black, 2 parts heavy French black, mixed with medium copperplate to the consistency of oil paint.

Cleaning the plate
Before applying the ink, the plate must be cleaned of all dirt and grease, and the edges must be filed and burnished smooth to prevent them holding ink, which will print as a crude linear frame around the image.

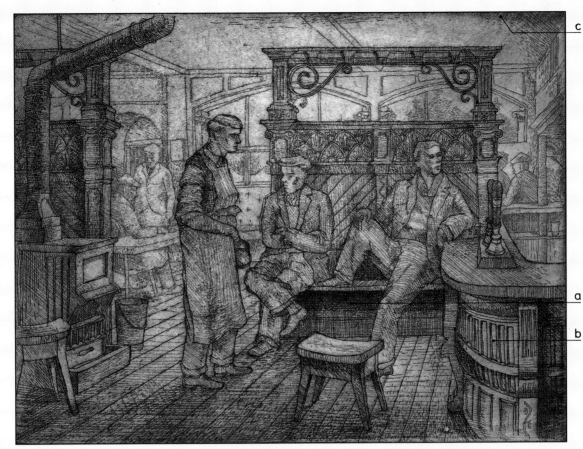

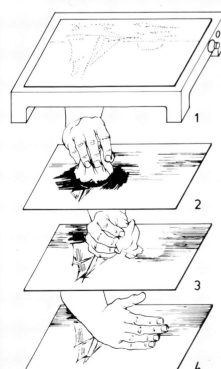

Inking the plate

1 Place the plate on the top of a warm hotplate.

2 Rub ink all over the warm plate with a dabber, ensuring that the lines are filled (the heat ensures that the ink melts slightly).

3 Remove the excess ink from the plate surface using a pad of tarlatan. Use a light sweeping action to leave the ink in the bitten or incised image.

4 Finish wiping the surface with a paper tissue held flat or use the side of the palm of your hand to polish and clean the unbitten areas. The hand should be lightly dusted with talc to give the best result.

Badly inked plate

The proof (*above*, reduced) shows evidence of very poor inking and wiping. Area (**a**) shows over inking; area (**b**) shows poor wiping; area (**c**) shows badly wiped edges. The detail (*below*, actual size) shows retained ink on the plate.

117

Printing intaglio

Care must always be taken to keep the inking activities separate from the printing process to prevent marks appearing on the print or surrounding margins.

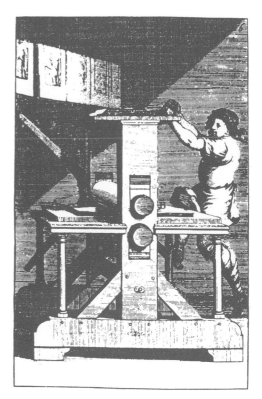

Intaglio press
An intaglio press is basically a heavy flat metal plank driven between two heavy metal rollers by a system of gears operated by a drive wheel. Heavy soft pressure is obtained by packing the press with wool blankets which mould the damp soft paper to the plate surface.

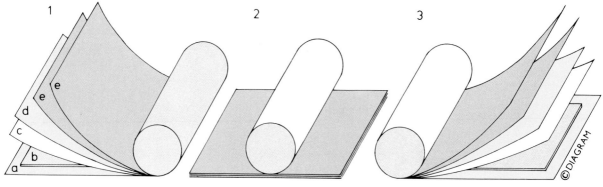

Pulling a proof
All intaglio plates are printed in the same way. First check that the edges and back of the inked plate are clean. Then check the bed of the press is clean.
1 Place blotting paper (**a**) on bed of press; place plate (**b**) centrally on bed of press with top edge parallel to impression roller and sides parallel to edges of press bed; place paper (**c**) on top of plate; place backing paper (**d**) (blotting or tissue) on top of printing paper; bring blankets (**e**) down on to plate and paper. Ensure that there are no wrinkles and that the blankets are straight.
2 Turn handle of press to print plate.
3 Raise blankets and carefully remove backing paper and print. Check print for quality, i.e. pressure, inking, wiping. Repeat the procedure for each print.
4 Handling proofs
To avoid finger marks on the margins of a proof, protect the surface by holding the paper between two paper hinges. Hold paper by diagonally opposite corners.

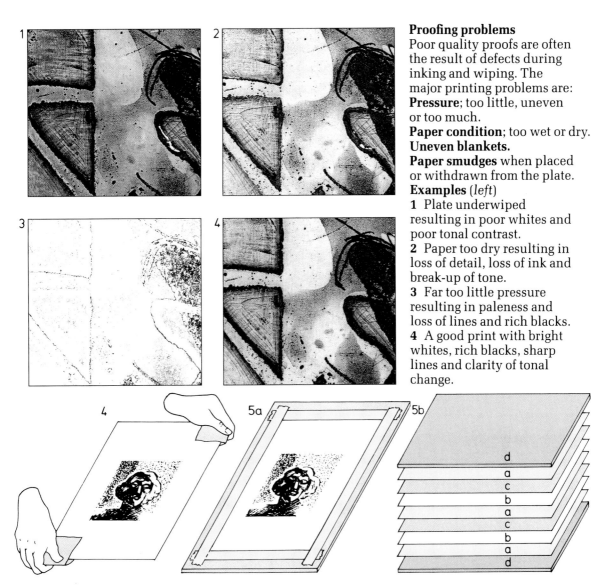

Proofing problems

Poor quality proofs are often the result of defects during inking and wiping. The major printing problems are:
Pressure; too little, uneven or too much.
Paper condition; too wet or dry.
Uneven blankets.
Paper smudges when placed or withdrawn from the plate.
Examples (*left*)
1 Plate underwiped resulting in poor whites and poor tonal contrast.
2 Paper too dry resulting in loss of detail, loss of ink and break-up of tone.
3 Far too little pressure resulting in paleness and loss of lines and rich blacks.
4 A good print with bright whites, rich blacks, sharp lines and clarity of tonal change.

Great care must be taken in lifting the paper as its moist condition can result in a tear. Paper can also stick to the drying underlay of blotting paper on the press.
5 Drying proofs
Two methods can be used:
5a Stretching; lay the proof on a clean board and paste down the edges using gum strip. This method prevents the edges from drying sooner than the centre and so avoids a resulting buckling of a dry proof.
5b Pressing; a more useful method for a series of prints. Onto a sheet of dry blotting paper (**a**) lay a proof (**b**) and overlay with tissue paper (**c**). This is covered with blotting paper and built up in sequence. The total quantity is then pressed between boards (**d**). Remove prints as soon as dry and flat. If necessary change blotting or tissue paper to avoid mould caused by dampness.

Correcting intaglio

Revisions to the incised lines in intaglio prints are achieved by removing the surrounding metal and raising the surface to its original level. Great care must be taken to clean and polish the new surface so that none of the earlier lines remain. Usually general areas of the drawing are removed rather than particular lines or tones. Revisions very often deaden the spontaneity of the drawing and are only employed when dramatic modification is necessary.

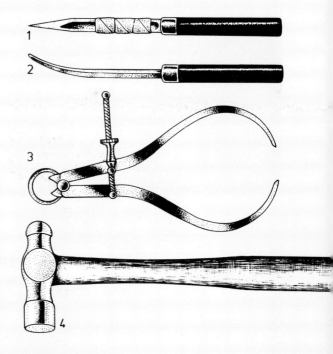

Basic revision tools
1 Scraper to pare away the surface.
2 Burnisher to polish the scraped surface.
3 Calipers to locate the scraped area on the reverse of the plate.
4 Ball and peen hammer to beat up the reverse side to level.

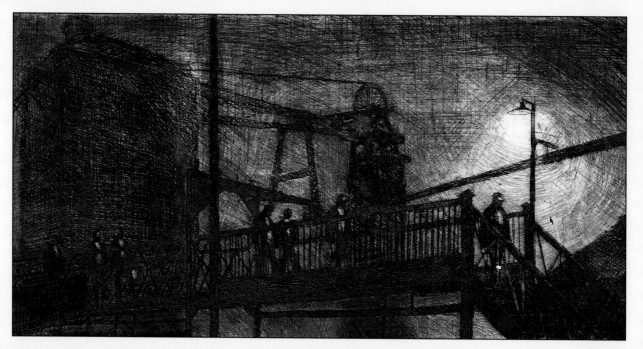

Procedure

1 Hold the scraper edge low and parallel to the plate, draw the blade across the surface like peeling an apple. Scrape lightly in several directions, removing a fine thin layer. Do not scrape too deeply too soon.

2 When the lines are removed, locate the area on the reverse with calipers and gently beat up the plate to its original level.

3 Polish the new surface with fine wire wool or metal polish, finishing with fine pumice powder to restore the smooth surface for redrawing.

For gentle modifications, the thinner lines can be softened by burnishing the surface and pressing down the area around the lines, and repolishing.

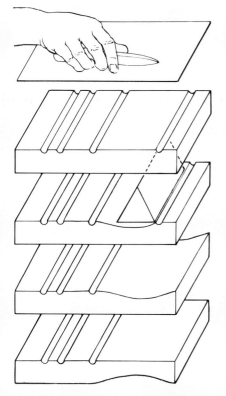

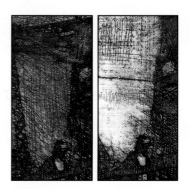

Plate states

The details (*above*, actual size) show the same area before and after revisions. The total design (*below*, reduced) shows how extensive were the revisions, and how the second print still requires considerable work to achieve a final result.

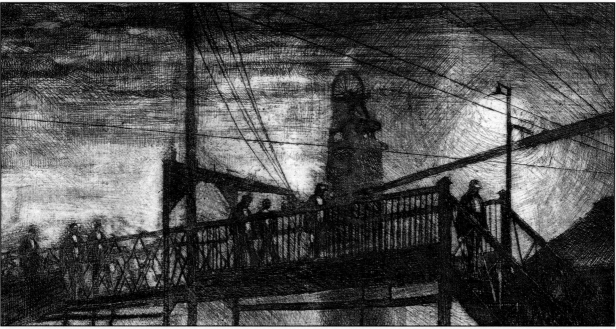

Experimental materials

Intaglio prints reveal the changes in surface from which the print was taken. Materials such as card and plastic sheet can be incised or built up, or have their surface changed by the addition of texture. Employing these methods can extend the range of alternatives traditionally available.

Raised surface techniques
Details (*left*, actual size) of three additional techniques.
1 Substance mixed with various materials (sand) to create a granulated surface.
2 Substances later scratched with etching needle.
3 Quick-hardening substances spread on the plate.

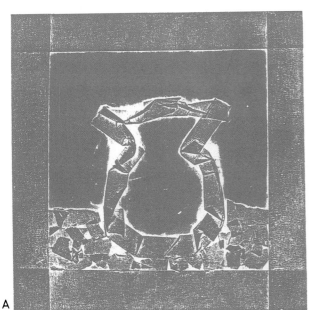

A

B

Added materials
Two proofs (greatly reduced) show the same plate printed by relief (**A**) and intaglio (**B**). The plate was made from sticking ribbons of masking tape onto mounting card. This method has great restrictions in subject matter as the tape does not allow for detailed drawing and often the textures produced are accidental. The detail (*right*,

actual size) shows clearly the surface qualities: porous card surface (**a**); differing levels catching ink (**b**); texture variants (**c**).
Avoid using excessive difference in height of materials added to the surface, and avoid textures with sharp peaks. These will cause your print to tear under pressure, or be too thick to print.

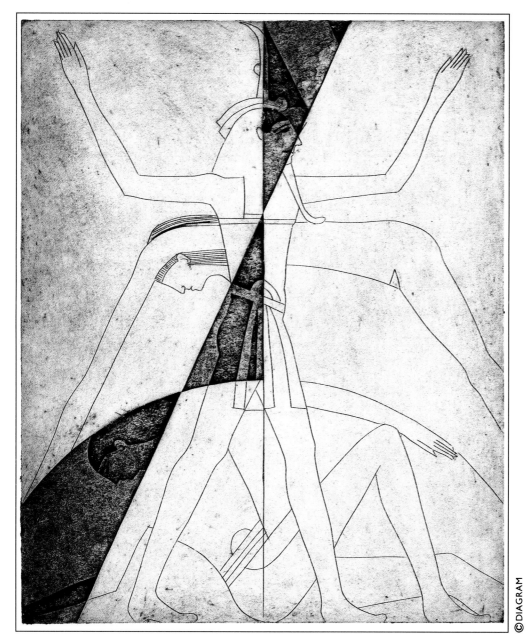

Lowered surfaces
Just as the increasing bitings of an aquatint produce darker tones, so the peeling away of card surface can create changing tonal values. The proof (*above*, greatly reduced) was engraved onto mounting card, then some of the layers of card removed to create darker areas. The detail (*right*, actual size) shows four levels: surface (**a**); first layers (**b**); second layer (**c**) and lower level (**d**).

123

Lithography: equipment

Lithography is a process invented in the late 18th century by Aloys Senefelder, in Munich, to reproduce with extreme accuracy fine pen lines (for music scores) and granular chalk textures (for portraits). This flat, planographic process offers a wide range of drawing possibilities and is used extensively as a commercial process. This book is printed by lithography.

Preparatory materials
Access to water is essential for processing and printing.
Gum arabic used pure or mixed with a small amount of acid to form a gum etch, to desensitize the undrawn areas making them resistant to grease and water retentive during printing.
Talc and **resin** to protect the drawing from the action of the etch solution.
Pure turpentine to wash the pigment out of drawn areas.
Asphaltum to reinforce the grease image after washing out with turpentine.
Counter etch a dilute acid to sensitize metal plates before drawing up.

Plates
There are three materials used for drawing surfaces:
A Zinc: most common in Europe.
B Aluminium; most common in America.
C Stone; the traditional Bavarian limestone blocks.

Resurfacing plates
Metal plates are usually returned to the supplier for resurfacing. Stones can be reground in the workshop.
1 Two similar sized stones are rubbed together with a mixture of sand and water. A heavy metal grinder, a levigator (**2**) is rotated over the surface (**3**) with sand and water. The final surface is ground with a muller (**4**) and a mixture of fine sand and pumice powder. Newly-reground stones should not have a hollow (**5**) or a bump (**6**) (both greatly exaggerated here), as these will affect the prints, leaving weak printed areas from the low parts of the surface. Absolute level is essential when printing from a surface.

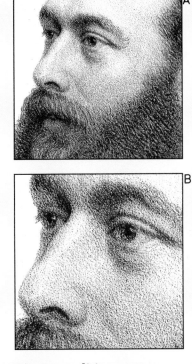

Texture qualities

The portrait (*left*, reduced) with details (**A** *above*, actual size and **B** enlarged) reveals the fine textural qualities of the stones. This excellently captures the granular detail of a chalk drawing.

2. Altrömische Kanne.

3. Altchristliches Goldglas.

1. Phönizisch-assyrisches Glas.

Detail qualities

Very fine detail is possible in a drawing if the plate texture is smooth. The print (*left*, actual size) was drawn with brushes and chalks. The original was printed in ten colours.

lithography: textures

The wide variety of line and tone possibilities makes lithography an ideal medium for capturing the qualities of watercolour, chalk drawing or pen drawing. The artist works directly onto the plate so is in control of all the qualities. These examples are all printed in the same size as the originals.

Experimental textures
1 Using the side of the chalk.
2 Drawing with pen and liquid drawing ink.
3 Solid areas of inks with a brush.
4 The same with pen lines.
5 Brush wash with dilute ink.
6 Ink diluted with turpentine.
7 Ink diluted with methylated spirit.
8 Gum stopped-out with wash and chalk overlaid.
9 Splatter.
10 Ink diluted with water.

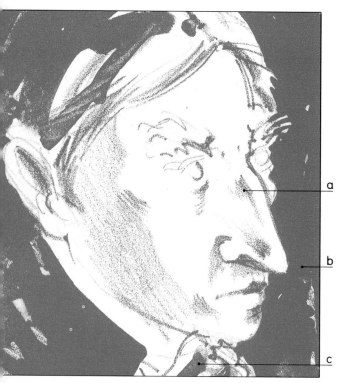

Test proof
A drawing produced for this book to illustrate the qualities of chalk (**a**) solid ink wash (**b**) and diluted drawing ink (**c**).

1

2

3

4

5

6

7

8

9

10

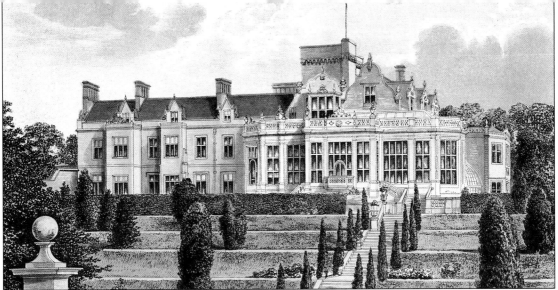

Detail
The original of the print (*above*) was printed in over eight colours and shows an enormous variety of tones and subtle effects.

Plate textures
Two differing qualities of plates were used for the print (*left*). One plate had a very smooth and fine grain, another had a coarse and rough texture. This enabled the artist to use chalks (**a**), then flat washes (**b**) and then fine brush details (**c**). The original is in four colours.

lithography: preparing stones or plates

Lithography offers the artist great freedom as the materials used in making the image are similar to those of conventional drawing – chalk, ink, brush or pen. Careful processing and printing ensures that exact reproduction of the drawn image can be achieved.

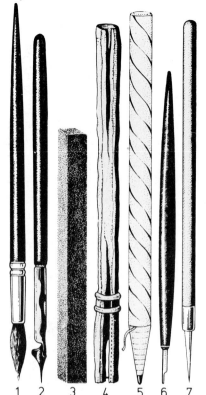

Tools and materials
Liquid litho drawing ink (tusche) can be diluted with distilled water or turps substitute and applied with a brush (**1**) or pen (**2**). Lines are achieved with a chalk stick (**3**), held in a chalk stick holder (**4**) or a pencil (**5**). Fine white lines can be achieved by scratching away the applied chalk with a pen (**6**) or a needle (**7**), which is used on stone only. Velvety tones are achieved by working rubbing inks onto the plate surface, and washes with diluted stick inks. Experiment with other materials – any grease-based drawing material, oil pastels, ball point pens, drawing through carbon – to find the most successful.

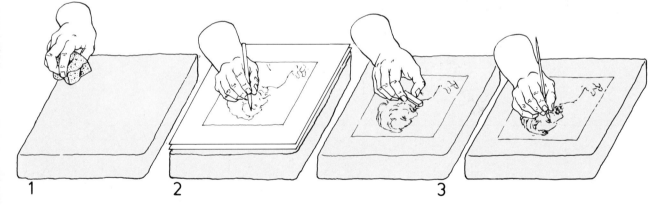

Drawing the plate or stone using a brush.
1 Paint a 1″ gum arabic margin around the edges of the stone and allow to dry.
2 Place the chalked transfer paper chalk side down on top within the gummed margins, and fix in position with adhesive tape. Place original drawing on top of transfer paper, and fix in position with tape. Using a hard pencil, and drawing with firm pressure, establish the main outlines of the image.
3 Remove drawing and transfer paper. A line image should exist on the plate surface. Using tusche dilute or full strength, a drawing can be developed with brush and pen to achieve line and wash. When dry, the drawing can, if required, be enhanced with the addition of chalkwork.
4 On completion of the drawing, process the plate or stone in the appropriate manner.

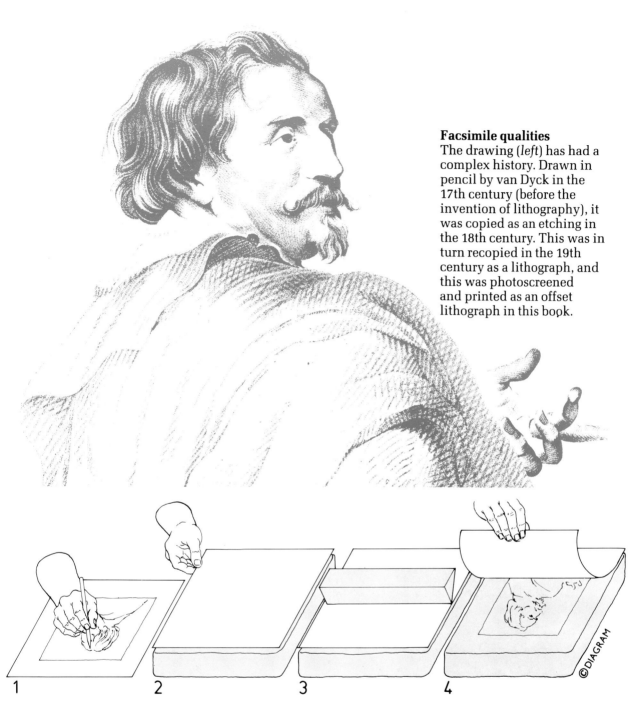

Facsimile qualities
The drawing (*left*) has had a complex history. Drawn in pencil by van Dyck in the 17th century (before the invention of lithography), it was copied as an etching in the 18th century. This was in turn recopied in the 19th century as a lithograph, and this was photoscreened and printed as an offset lithograph in this book.

Transfer method
Transfer paper is thin and has one side coated with a water-soluble gum. The drawing is made with lithographic chalks and inks on this side of the paper (**1**). On completion, the drawing is placed face down onto a damp plate or stone (**2**) and run through the press several times (**3**). When the paper becomes transparent, it is carefully removed (**4**) and the dry plate may be worked further with chalks and ink.

Negative method
On toned backgrounds, white lines and shapes can be drawn in gum arabic and allowed to dry. This forms a barrier to any ink or chalk applied to the area containing lines or shapes. On stones, they can be scratched or scraped out. On plates, chemicals are used if whites are introduced after the area of tone has been drawn.

129

lithography: processing the plate

Processing the plate is the stage after completing the drawing and before printing. It is intended to ensure that all white areas are clean and free from grease, and that all the areas that will print are strongly established on the plate surface. It is necessary to have access to running water and a fan so that the plate can be dampened and dried during various stages.

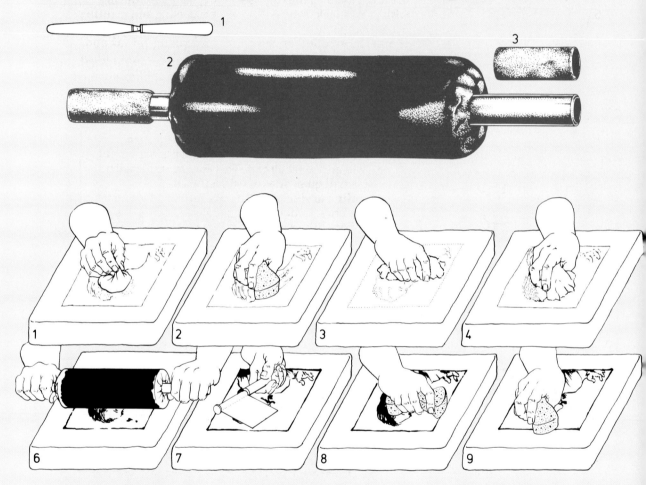

Processing the image

1 On completion of drawing, generously dust the image with talcum. Lightly remove excess.

2 Using a sponge or clean muslin cloth, dab a thin film of gum etch across the entire surface, taking care not to smudge the drawing. Leave gum to dry for 30 minutes to an hour.

3 Wash image with genuine turpentine using clean soft cloth. Image will disappear.

4 Apply a thin even coat of asphaltum to the image.

5 Wash entire plate surface with running water to remove gum. A pale brown image will emerge.

6 Keep plate damp with sponge and water and roll up image in press black until required strength is achieved. (At this stage corrections, alterations, etc., can be made. Use appropriate chemicals according to manufacturer's instructions.)

7 Fan plate dry and dust image with resin first, then talcum. Lightly remove excess.

8 Apply second gum etch as before and leave for a

Equipment

1 Palette knife for mixing inks.
2 Lithographic roller for inking image. A nap roller made of suede leather for use with press black only. A glazed leather or composition roller for use with printing inks.
3 Leather grip fitted to handle of roller prevents friction burns on hand as roller spins during inking.
4 Sponge.
5 Fan; electric or manual for drying plates during processing and printing. Smooth surface for mixing and rolling out ink and press, direct pressure or offset for printing.

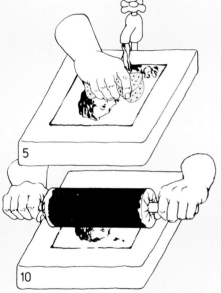

minimum of three hours to allow the desensitizing action of the acidic gum to take effect.
9 Repeat **3**, **4** and **5**. Wash with turpentine, apply asphaltum, wash with water.
10 Keep plate damp using sponge and water, roll up plate, fan it dry and print in appropriate colour using lithographic printing inks.

Materials

Gum etch for desensitizing plates, i.e. to make the undrawn parts of the plate resistant to grease when wet. This is gum arabic with small quantities of acid added to it.
Gum arabic used to form the base of gum etches, which can be purchased ready-made from lithographic suppliers.
Counter etch; a dilute acid used to resensitize metal plates for reuse. A newly-grained plate can be erased, resensitized and redrawn up to three times before regraining.
Erasing chemicals in liquid or paste form used to remove unwanted marks on plate or stone.
Resin and **talcum** used for dusting drawn and inked images to protect them from the action of the etches.
Plate etch can be purchased from suppliers. Used to make gum etches. Rarely used undiluted as they are strong and can weaken the drawn image.
Turpentine used for washing out image after gumming plate.
Asphaltum used to reinforce grease content of image after washing out with turpentine.
Sponges for gumming and damping plate or stone. One sponge for gum only and one sponge for damping only.
Press black; a stiff greasy non-drying ink used to establish the image at the midway stage when corrections, erasures, etc., can be made.
Litho varnish of various consistencies used to soften or stiffen printing inks.
Lithographic printing inks.

lithography: *inking and printing*

Printing requires care. As a general rule do not use any materials, equipment, machinery or chemicals relating to any print process if you are ignorant of their use. This will not only prevent accidents or damage but will save wasted effort and ensure better results. Build up the image slowly. Do not overink or overpressure the press. This will cause the image to spread and coarsen with loss of detail. Clean up all surfaces after use.

The press
There are two methods of printing:
1 Direct pressure; the plate or stone covered by a tympan on the bed of the press passes underneath a scraper bar. Prints made with direct pressure are reversed left to right.

2 Offset; transfers the image from the plate to a roller covered with a rubber blanket and then to the paper. The image prints as drawn, not reversed.

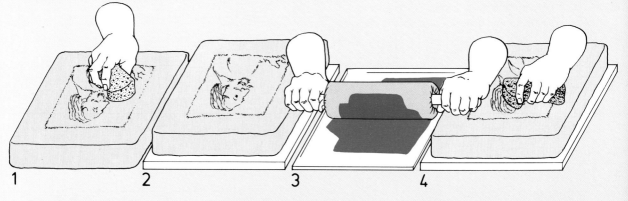

Printing the stone
1 If the stone has been stored in a gummed state, use the washing out process to prepare the stone to receive ink. Wash with turpentine, apply asphaltum, wash with water.
2 Place stone on bed of press.
3 Mix and roll ink of a suitable consistency on a palette.
4 Dampen the stone with water.
5 Build up the image slowly to required strength by inking with a roller.
6 On completion of inking, fan the stone dry.
7 Place paper in correct position on the stone, place packing on top of printing paper.
8 Lower tympan and operate the press.
Repeat the process for each print. It usually takes two or three prints to bring the image up to full printing strength.

If the stone is to be reprinted at a later date, gum up, allow to dry. Wash with turps,

Problems with prints

PROBLEM	FAULT	REMEDY
Image filled in	Overinked	Damp plate; mop off ink by quick rolling
	Too much pressure	Reduce packing or pressure
	Too much asphaltum used in processing	Gum up, wash out with genuine turpentine and use a stiffer ink
	Ink too soft	Clean palette plate and roller; treat plate as above and use a stiffer ink.
Image faint	Ink too stiff	Reduce ink with litho varnish
	Insufficient pressure	Increase packing or pressure
	Etch too strong	Resensitize plate or stone, redraw and reprocess.
Streaks	Faulty scraper	Replace
	Creased packing	Replace
	Damaged tympan	Replace

©DIAGRAM

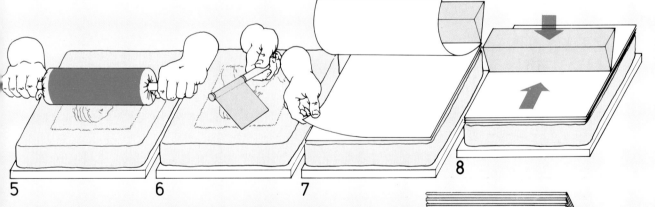

5 6 7 8

apply asphaltum and allow to dry. Do not leave inked image on plates or stones.

Storing prints
Each print should be stored individually to prevent the ink from smudging or transferring to other surfaces. This is normally done in drying racks or can be achieved by hanging each print on a line.

Screen printing

Screen printing is a stencil process whereby ink is forced, by the pressure of a squeegee, through the open areas of a stencil attached to a stretched fine meshed fabric. It will print easily on any flat surface: paper, fabric, plastic or glass. Screen inks are semi liquid, strongly coloured and opaque to give maximum colour value.

Screen print
The poster (*above*, reduced), with detail (*left*, actual size), is a good example of the qualities of screen printing as it shows the ability to achieve solid strong areas of colour.

Tools
The two main requirements are a frame across which a fine mesh holding the stencil is stretched, and a squeegee to force ink through the stencil.

Stencil methods
There are four main stencil making methods: gum stencils (**1**), cut stencils (**2**), profilm stencils (**3**) and photographic stencils (**4**).

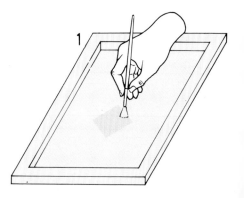

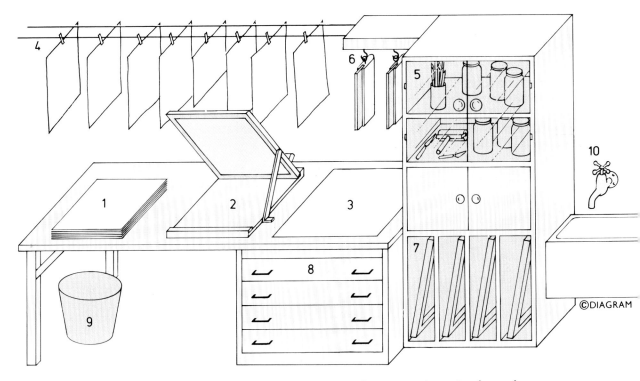

Layout
A large worktop with an area for:

1 The prepared sheets of paper needed for the edition.
2 The printing frame and screen with squeegee.

3 A surface on which to dry the prints, or:
4 A hanging frame for drying prints.
5 A store cupboard for inks, solvents and tools.
6 A rack for spare squeegees.

7 A storing frame for spare screens.
8 A plan chest for prints and paper.
9 A large waste bin.
10 Access to running water.

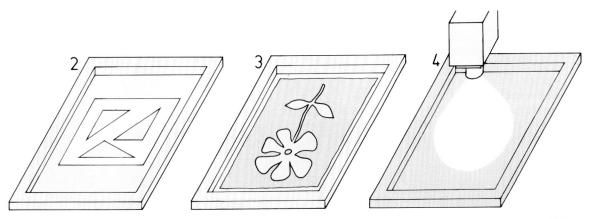

screen printing: equipment

The frame and the squeegee are the two printing implements, and both can be constructed by a simple method. The size of screen limits the size of the print, so you must consider the implications before beginning construction. Frame size is usually related to a standard sized paper sheet. The print area is located centrally within the dimensions of the screen, allowance being made for margins around the print.

Mesh size
The size of mesh affects the quality of the detail. Large open mesh (**a**) is used for large pattern effects and fine mesh (**b**) for detailed photoscreens.

Stretching the screen
Cut a rectangle of mesh, about 4″ (10cm) wider and taller than the frame. Stretch and staple a narrow edge over the frame, working from the centre out to the corners (**1**). Secure the opposite edge, ensuring that the screen is kept taut and square (**2**). Repeat on the two adjacent sides. Wash the screen carefully (**3**), then apply a degreasing paste to the underside of the screen, turn it over and apply to the inside (**4**). Finally, after allowing the paste to work on the mesh for a few minutes, wash away all the paste in cold water (**5**).

Masking the screen
To prevent seepage of ink and to provide a reservoir for ink during printing:
1 Lay gum strip on the underside of the screen to cover both the mesh and frame at the point where they meet.
2 Reverse the screen and, with gum strip folded along its length, seal inside edges of the frame.
3 An additional strip of tape is laid alongside the first. Repeat this on each inside edge.
4 Extra corner pieces may be added for reinforcing the weakest point in the seal. Coat the gum strip thinly with shellac to protect it during washing and cleaning after the colour has been printed.
Any open screen between the print area and tape should be sealed with a filler and dried before the screen is used.

Printing frame
The stretch frame is placed in position with the mesh in contact with the baseboard, i.e. the inside facing towards you. A small swing prop is attached to the outside edge of the frame and rests against a block on the edge of the baseboard to support the frame in between printings.

Frames

Frames are constructed from 1½″ × 1″ (38mm × 25mm) planed wood. The corners can be joined either as tongue joints (**a**), overlapping joints (**b**) or mitred (**c**). They are further strengthened after gluing by countersunk screws. The construction must be square and firm as a weak frame will not endure the tension of the fabric mesh stretched over it. Each frame is then positioned on a flat bed and hinged with split pin hinges (**d**). This enables you to remove the pin to change the frame (**e**) as each new stencil is made to print other colours.

Squeegees

To construct a squeegee, cut a groove in a block of wood (**a**) large enough to grip a strip of rubber or soft polyurethane (**b**). Glue in position and screw through to hold firmly in place. Stick a small block of wood on the side of the squeegee to help support it when it is resting after printing.

screen printing: stencils

The most elementary way to create images from a screen is by a cut stencil. The removed portions allow the ink to pass through the screen. Stencil designs need not have bridging elements as the 'free' items are retained in position by sticking to the screen. Paper stencils are good for short print runs, but for long runs you need cut film stencils.

Paper stencils
1 Using thin paper, such as newsprint or tissue, cut out your design, taking care to retain all the loose elements.
2 Reassemble the stencil in the central area of a sheet of proofing paper.
3 Cover with the screen.
4 Holding the squeegee blade at an angle of 45°, draw the ink across the screen.

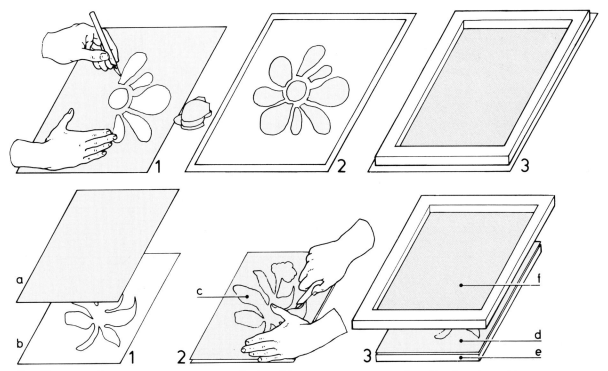

Cut film stencils
These are produced in a similar way to paper stencils, but, being gelatine-based, are stronger and more able to take detailed cutting. Available rolls of material have differing methods of attaching to the screen so follow the manufacturer's instructions carefully.
1 Place a piece of film (**a**), backing side down, over your design (**b**).
2 Using a scalpel, cut away the areas intended to be printed (**c**).
3 Place the backing sheet (**d**), with its retained masked parts, on a board (**e**) which is smaller than the screen area, and lay the prepared screen (**f**) down onto them.
4 Lightly dampen the surface of the screen with a sponge and appropriate stencil solvent, making sure there are no air pockets. Too damp a surface causes the stencil to dissolve and creates fuzzy edges.
5 Remove surface dampness with blotting paper or newsprint, then stand the screen to dry overnight, or dry with a fan heater.
6 When completely dry, gently peal off the backing sheet, taking care that all

The ink will pass through the screen and onto the stencil, and the cutaway areas exposing the proofing paper will print the design.

5 When the frame is lifted after the first printing, the paper pieces forming the stencil should remain held in place on the mesh by the sticky ink.

Japanese paper stencil (*right*, reduced).

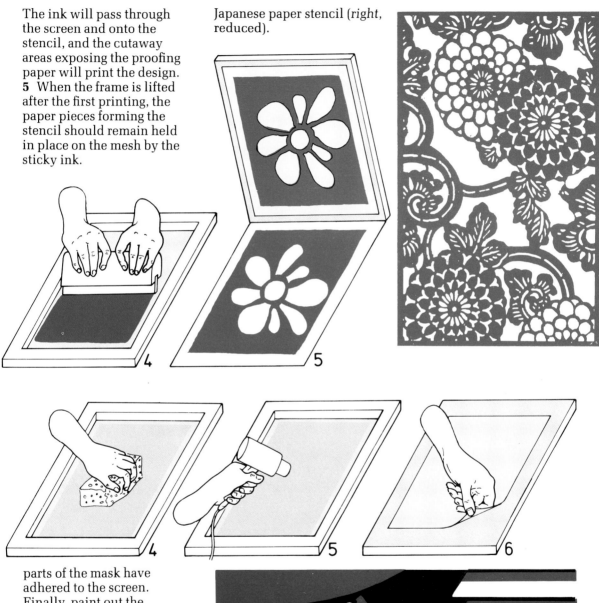

parts of the mask have adhered to the screen. Finally, paint out the surrounding areas with screen filler to ensure a clean edge to the design.

Detail (*right*, actual size) of a cut film stencil.

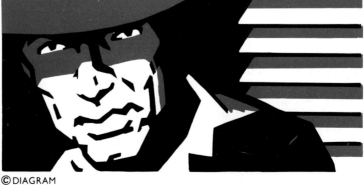

©DIAGRAM

139

screen printing: methods

Drawing designs by hand gives you greater freedom as the shapes are not restricted to ones cut by scalpel. This is particularly important with lettering and free designs. Usually hand-applied methods allow you to clean the screen after use and to store it for further designs.

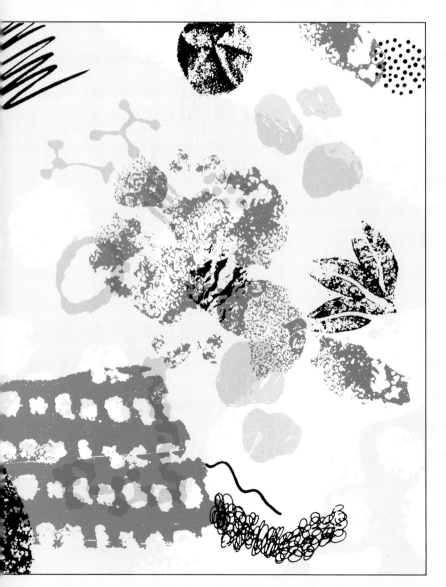

Simultaneous colour prints
Draw the design directly into the mesh with soft oil pastels (**1**). Use a mixture of 50% white spirit and 50% extender base as the printing medium. Pull a quantity of this mixture across the screen, using a squeegee

Blocking out method
Transfer the design details down on to the screen (**1**). Raise the screen free of contact with other surfaces and, using a fine brush and a solution of screen filler,

Wax resist method
This works on the principle of grease and water being incompatible. The image is drawn directly onto the screen using soft wax crayons (**1**) or liquid wax (tusche) and allowed to dry. A water-based gum of

Experimental methods
The example (*left*, actual size) shows the results of drawing with pens, brushes and soft wax crayons, some in positive black and others in negative white.
Resist experiments
Numerous textures can be obtained by exploring the method of drawing with

with firm pressure (**2**). If the
print is weak, put a new
sheet of paper in place and
repeat the pull in the same
direction as the first, using a
further quantity of extender
that has been reduced with a
little more white spirit.

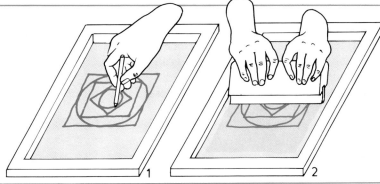

paint out all the areas
intended to be white (**2**).
Check that the filler has
produced a total opaque area
by holding the screen up to
the light and checking for
pin point holes.

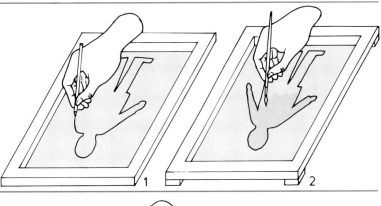

appropriate consistency is
squeegeed across the entire
surface and allowed to dry.
The greasy image resists the
gum and should wash out of
the screen with turps
substitute (**2**), leaving open
areas that will print as the
drawn image.

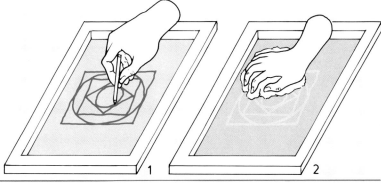

grease onto the screen.
1 Soft wax crayon rubbed
over a screen when pressed
onto a rough surface.
2 Soft wax crayon rubbed
onto screen with a smooth
surface beneath.
3 Soft wax crayon over
crumpled paper.
4 Liquid wax dribbled onto
the screen.

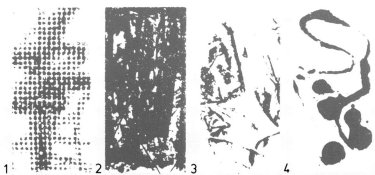

screen printing: phototransference

Phototransference of the image onto the screen enables you to include elements which would be impossible to draw or cut from stencils: halftone photographs, converted by a dot grid, or text produced by typesetting. The basic principle is that areas of emulsion exposed to ultraviolet light harden to become insoluble in water; unexposed areas remain soluble and can be washed out to open the screen, allowing ink to pass through.

Halftone film
When the tonal qualities of a photograph or drawing need to be converted to a screen, an intermediary grid is applied which converts the tones to a structure of tiny dots. The detail (*left*) shows an enlargement of these on a screen.

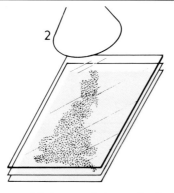

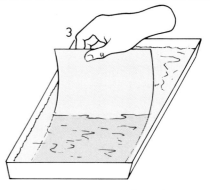

Indirect method
This is more convenient to use as the film is produced in darkened conditions, then transferred to the screen in daylight. The screen is degreased to ensure photo-sensitive stencil material will adhere to mesh.
1 An exposure layer is prepared with a sheet of light sensitive stencil film (**a**) with its emulsion side down, under the positive photographic film (**b**) with its emulsion side up away from the stencil film, and a sheet of glass.
2 Using the experience of earlier tests, the film is exposed to ultraviolet light.
3 The film is then developed. (You can, however, get material which you just expose and wash out, with no developer used.)
4 This is then washed in lukewarm water and the unexposed areas will wash away forming a stencil.
5 The stencil film is placed with the emulsion surface in contact with the underside of the screen mesh.
6 The two surfaces are now pressed firmly together by

Direct method

1 The screen is first degreased to ensure the photosensitive emulsion will take to the surface.

2 Working in subdued light, a screen is thinly and evenly coated with a light-sensitive emulsion, and thoroughly dried.

3 The prepared positive film is then placed with its emulsion side face down onto the screen and a sheet of glass is placed over them to ensure that both surfaces are in contact.

4 The screen is then exposed to ultraviolet light after first experimenting with exposures to discover the sensitivity of the emulsion.

5 After exposure, the screen is washed in warm water to remove emulsion from the unexposed areas. The exposed areas are protected by a hardened layer of emulsion.

6 The screen is then dried and examined for tiny pin holes which can be sealed with a coat of filler.

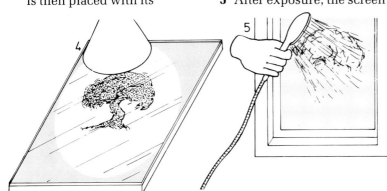

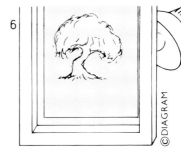

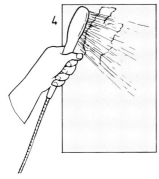

placing the screen underside down on a flat surface and rubbing the mesh through a sheet of blotting paper.

7 The screen is now thoroughly dried.

8 The thin plastic backing sheet can be removed. Finally any open areas in the margins and pin holes can be painted over with a filler as above.

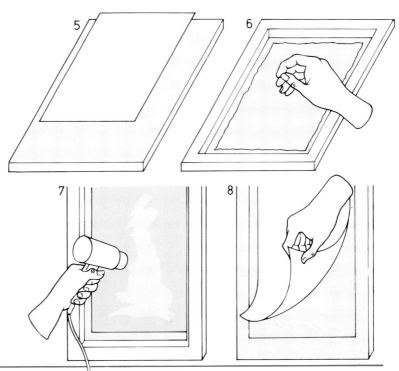

143

screen printing: colour

Using the screen printing process to achieve coloured results involves you in difficulties of registration. A simple way to obtain bright results is to print the designs with a mixture of inks in the screen trough. Overprinting with translucent inks offers more colours than the initial ones used, but cut masks with a small overlap of the colours to avoid white gaps appearing between colours. Opaque inks require you to print the larger areas first and to overprint the smaller areas.

Colour print
The detail (*right*, actual size) shows the effect of overprinting two screens (screen **1** and **2**, *far right*, reduced) to produce the three values.

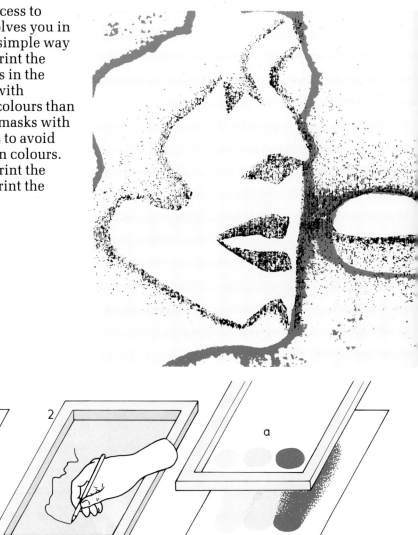

Registration
1 To achieve an accurate registration of each screen, begin by placing a proof of the first colour (**a**) on the printing bed. Glue thin paper tags (**b**) to the base at the corners of the first print.
2 Bring down the screen and trace off the main details of the original design, then remove the screen and produce the second colour stencil. Return the screen to the printing frame and begin printing as you insert each earlier proof against the registration tags.

Colour merges
An attractive way to achieve colourful effects is to place a group of colours in the trough (**a**) and, when running them across the screen, they will merge and can create unusual colour qualities.

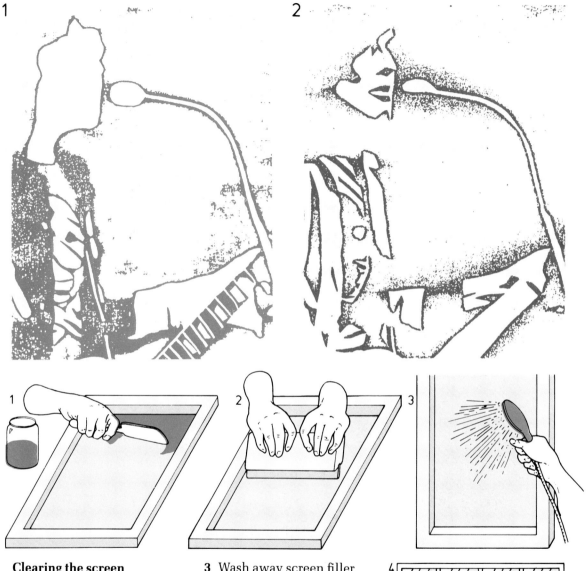

Clearing the screen
After completing the edition, the images on the screen can be removed and the screen reused.

1 Collect and store the surplus ink in an airtight container.

2 Clean the screen of all ink with an ink solvent drawn across the screen with a squeegee, then wipe with rags.

3 Wash away screen filler with water and then remove the stencil elements, using the appropriate manufacturer's stripper solvent. Use a shower spray to wash the screen thoroughly clean.

4 Allow to dry and store vertically in a rack.

Duplicating machines

Printmaking using specialised duplicating machines usually produces inferior quality results. Nevertheless, the methods can be used satisfactorily for printing ephemeral items. There are four methods commonly in use: the screen duplication; the dyeline duplication; the photoelectric copiers and the spirit duplicator.

Stencil duplicators

Stencil duplicators work in the same way as screen printing. The ink passes through a screen onto the paper. Machines can be either flat bed or drum.

Drum duplicators

The drawings on a stencil can be produced with a ball point pen, or more successfully with a special stylus. Only lines are possible and care must be taken to keep the drawings free and open. Text can be added by placing the stencil in a typewriter and typing the words without the carbon in the machine. Prior to typing, clean the heads of the letters so that they produce a clean impression on the stencil. Electronically scanned screens can convert your artwork to a stencil, but these require specialised machines and are only useful if you are doing many designs.

Flat bed duplicators

These machines operate in the same way as drum duplicators but each print must be individually inked. Using a similar stencil as a drum printer:

1 Squeeze a strip of ink along the top section of the screen.

2 Fix the stencil under the frame by rolling ink along the screen.

3 Place support and print paper under the frame and run the rod down across the screen surface, forcing the ink through the screen and stencil onto the paper.

Dyeline method

Dyeline or Diazo machines print same size line originals. The method was developed to enable engineers and architects to duplicate their drawings so the size of your original is governed by the width of the paper feed on the machine. It requires preprocessed photosensitive paper which is fixed by an ammonia solution or by semi-dry developers.

1 Draw your design on a transparent surface. Inks, pencils or chalks can be used. Words can be added by transfer-down lettering; textures by spraying with inks or rubbing.

2 Adjust the machine to the correct exposure; feed in the master drawing (**a**) and photosensitive paper (**b**) into the machine.

Colour
All copy machines produce black line results so colour can be added by printing on coloured papers, by adding areas of colour by hand, or both.

Formatting
The results of the printing methods can be:

1 Folded to form a standing card.

2 Bound in a variety of methods.

Sizes
It is always best to design your master to be printed on normal stationery format papers as these are cheaper to buy than special paper sizes. Photocopy machines have a reducing facility, which increases the sharpness of the image.

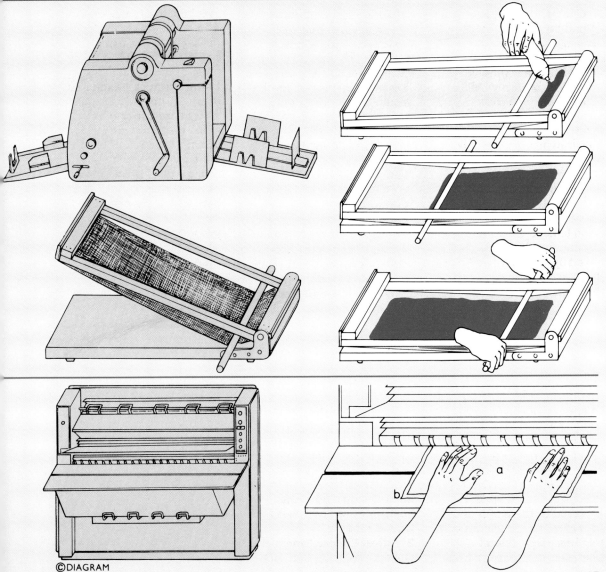

duplicating machines

Photoelectric machines

There are two types of photocopying machine: a direct copy process which requires photosensitive paper, and an indirect copy process which can print on ordinary paper. All machines allow only for black and white text and pictures, and most are unable to retain the range of tones in a photograph.

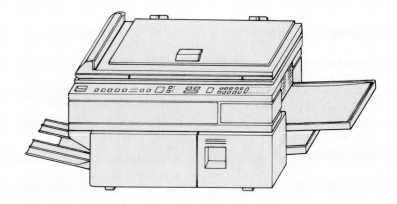

Advantages and disadvantages

The most useful aspect of photocopiers is the easy method of printing. After originating your master artwork, it is simply a matter of setting the controls of the machine to the required exposure and quantity. The disadvantages are that the design is printed in only black and that every part must be in line, with poor results when printing gradations of tone. The paper sizes should be standard stationery dimensions to facilitate easy feeding into the machine.

Preparing artwork

The master artwork is normally thin card onto which text and pictures are pasted. Pictures can be photographs or drawings but they must be the correct size for the area they occupy. The text can be handwritten, typewritten, transfer-lettered or typeset.

Costs

In addition to the normal material costs, photocopier manufacturers charge for each print produced, if the machine is leased. Remember, when calculating, to include a percentage of any other standard costs such as hire costs and maintenance costs.

CHILDREN'S PARTY

24TH NOVEMBER

From 5pm to 7pm
at Janet and John's house
19, Kimberley Road, Hampstead

All ages between 2 and 9
are very welcome

Spirit duplicator

Only suitable for short runs when good quality prints are not essential. First draw your design on a master with a dyesheet underneath. (You can produce multi-coloured prints by changing the dyesheet.)

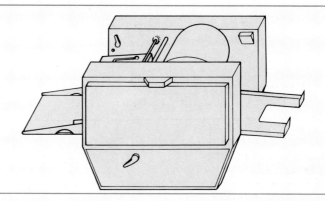

Problems

If the controls of the machine are not correctly set, you will have small shadows appearing where the edges of your artwork have been assembled. This can be avoided by painting over the stuck edges with white typewriter correcting fluid.

Small format designs

When considering a quantity of over 100 prints of a small design, you can mount up duplicates of your artwork with the resulting prints producing two or four copies of the original. These can then be cut up.

Photographs

Using photographs in a photocopy technique means that you have to adapt the image to a line conversion. This can partly be achieved by copying the photograph, then copying the copy. Each subsequent copy of a copy will reduce the image to its basic line elements.

© DIAGRAM

Making copies

Place a dyesheet (**a**) with the dye side upwards on a hard surface (**b**). Lay the master sheet (**c**) matt side upward on top and draw your design with a biro or pen. Clip the master round the machine drum, pump transfer spirit into the machines, adjust the pressure and begin running the press.

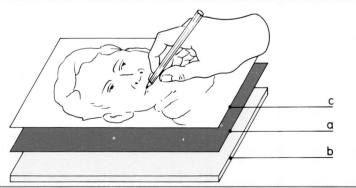

c
a
b

Part Four

tenuto per la falda della sopravvesta a un ferro della cateratta. Francesca, a quella vista inattesa, getta un grido acutissimo, mentre lo Sciancato si fa sopra all'adultero e lo afferra per i capelli forzandolo a risalire.

GIANCIOTTO.

Sei preso nella trappola,

ah traditore! Bene ti s'acciuffa

per queste chiome!

La donna gli s'avventa al viso minacciosa.

FRANCESCA.

Lascialo!

Lascialo! Me, me prendi! Eccomi!

Il marito lascia la presa. Paolo balza dall'altra parte della cateratta e snuda il pugnale. Lo Sciancato indietreggia, sguaina lo stocco e gli si avventa addosso con impeto terribile. Francesca in un baleno si getta tra mezzo ai due; ma, come il marito tutto si grava sopra il colpo e non può ritenerlo, ella ha il petto trapassato dal ferro, barcolla, gira su sé stessa volgendosi a Paolo che lascia cadere il pugnale e la riceve tra le braccia.

FRANCESCA, morente.

Ah Paolo!

Lo Sciancato per un attimo s'arresta. Vede la donna stretta al cuore dell'amante che con le sue labbra le suggella le labbra spiranti. Folle di do-

150

WORDS AND PICTURES

lore e di furore, vibra al fianco del fratello un altro colpo mortale. I due corpi allacciati vacillano accennando di cadere; non danno un gemito; senza sciogliersi, piombano sul pavimento. Lo Sciancato si curva in silenzio, piega con pena un de' ginocchi; su l'altro spezza lo stocco sanguinoso.

Words and pictures combined

Image printing and word printing are closely linked activities. The methods available for duplication of images are also used for words. Fine prints frequently included words as a decorative element, and texts included images for the same reason. Posters, covers for publications, images alongside texts in books, and every other form of graphic communication, have words and pictures combined.

Letterforms may be hand-drawn in the style of the artwork or included by mechanical means such as photography or typography. Whatever method is employed, it is essential that you view the total effect of the elements and avoid considering the art as an independent feature of the print. A rudimentary knowledge of typography and the legibility of letterforms helps you judge the balance of text and pictures.

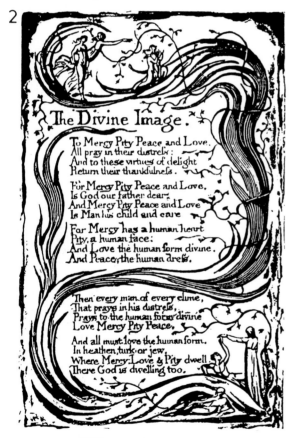

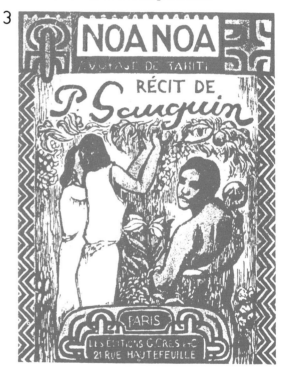

The first printed images were combined with text to enhance the printing of information. Later artists used the opportunity to reverse the role and included words and texts in their designs.

1 A 16th-century woodcut of an initial letter, the first letter of the first word in the first sentence. This design is of a 'U' which was then hand-coloured on the original proof.
2. An 18th-century relief etching (reduced) in which the text and pictures are combined to form an overall design.

Applications

The poster and label are two opportunities to combine the word and picture:

A A poster printed by screen printing.

B A bookplate printed by letterpress.

A

B

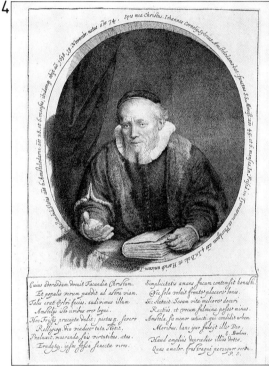

4

5

3 A 19th-century woodcut (reduced) of the cover of a book, printed in the original in several colours.

4 A 17th-century etching (reduced) includes extensive text. This form of letter creates very serious problems for the artist for, although it appears to be handwriting, it is in fact written on the plate in reverse.

5 A 19th-century woodcut of a calendar in which the words and letters form the total image. Each letterform has been transformed into abstract patterns, the top series being J U N N E R.

6 Originally an Oriental device, the printing seal transforms the letters or characters to a pattern.

6

Selecting lettering

Selecting the correct letterform for your print requires you to have a wide experience of alphabet forms. Collect examples whenever possible. Take care to evaluate the compatibility of selection. The means of incorporating the letters may be by hand, transfer, photography, or by stencil.

Inclusion
The letters within this large image (*right*) were hand-drawn to blend with the quality of the lines in the illustration. The shapes in the drawing influenced the artist in the style of letters forming the words.

Cut letter forms
This linocut (*right*) of individual capital letters was done by a 16-year-old student who adapted the regular style to a more free and irregular one. The imperfections of cutting and printing add to the charm of the letters and, when combined into words and included with a lino image, create a bold and strong contribution.

abcd

abcd

Choice
The selection of a letterform depends on the intentions but it must always maintain an element of legibility. There are hundreds of varieties of shapes which can be selected to represent the letters of the alphabet.

Style
Exotic styles are often best as they avoid the difficulty of accurate interpretation. Precise letterforms mean that great care must be taken in duplicating the shapes within your design.

Means
There are many ways of obtaining the letters.
A Dry transfer; preprinted alphabets which are pressed into the required position.
B Stencil templates; cut letterforms which are brushed through to the design or traced through.
C Sketched by hand, using pencils, brushes or pens.

selecting lettering

All letterforms must portray the character they represent, otherwise the words in which they appear will be incomprehensible. Nevertheless, words incorporated in prints have a wide range of possibilities of distortion by shape, structure and features. Begin with simple forms and develop changes to suit the surrounding images in your print.

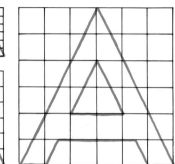

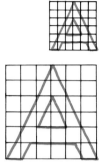

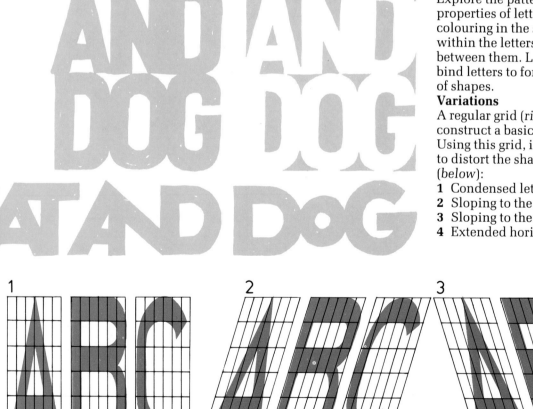

Size
Basic grids superimposed over the letters can be enlarged or reduced to enable you to retranscribe them in a different size.

Shape
Explore the pattern properties of letters, colouring in the spaces within the letters and between them. Link and bind letters to form clusters of shapes.

Variations
A regular grid (*right*) helps construct a basic alphabet. Using this grid, it is possible to distort the shapes into (*below*):
1 Condensed letters.
2 Sloping to the right.
3 Sloping to the left.
4 Extended horizontally.

4

Hand-drawn lettering

When creating words, do not embark on a slow and laborious method. Single words are easy, sentences difficult, and paragraphs require mechanical techniques such as typing or typesetting. Hand-produced lettering is most successful when you consider the end result before beginning. You can draw them by hand, copying from published alphabets, invent them yourself, or use stencils or dry transfer letters. Without calligraphic or design skills, the preformed alphabets are the best because it is just a matter of arranging the letters in the required order. Those letterforms which are created without confidence or experience are most likely to look unsatisfactory and distract from your design.

Whenever you do lettering, it should be done independently of the artwork in the design and added afterwards.

Hand-drawn
Hand-lettering is the least expensive and the easiest to do, but it requires confidence and experience. Try to build up a consistent style by practising on spare sheets of paper before you draw your words.
Begin with a row of guidelines, which indicate the body height (**a**) and the maximum height (**b**), the ascenders, and maximum depth (**c**), the descenders. Try to establish an angle for the lettering by the flow of your pen or by the guidelines drawn (**d**).

Cut out technique
Cut out lettering works best when each letter is selected from a different size or style. The irregularity of the shapes becomes an attractive feature of the assembled group of letters. In addition, the alignment and unusual juxtaposition give the word an arbitrary and irregular appearance.

Traced letterforms
If you are involved in producing prints in which words regularly appear, then collect styles of lettering from as many sources as possible. By using tracing paper over the shapes and adapting the forms already published, you can achieve unique solutions to the words on your design.

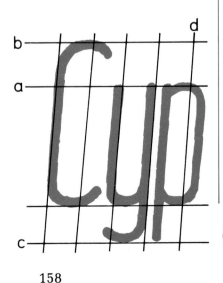

©DIAGRAM

Stencil

Stencil letters are very useful for large words. They are difficult and laborious to use in small sizes with continuous text. Alphabets are available on a complete template (**a**) or as individual letters (**b**).

First draw guidelines for the base of the letters. Place each stencil in the correct position and trace the outlines of large letters onto the card. These can then be carefully filled in, using a larger drawing implement.

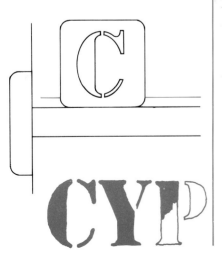

Dry transfer

Dry transfer lettering gives a well-finished look to your headings.

1 Draw light blue guidelines for the base of each line of copy on good smooth card.

2 Rub down the letters with an old ball point or soft pencil.

3 Pay special attention to the space between letters as this must give the appearance of being equal, but is really visually spaced with more space between vertical letters than letters with sloping sides. It is often useful to trace the letters off first and to consider the spacing before transferring down. Mistakes can be corrected by pressing a piece of masking tape over the offending letter, which is removed when the tape is lifted.

To align characters on work where no rules should be visible, draw a light line in pencil on the card below where you want the lettering to appear. Place against this line the tops of the letters of the line below the one you are using on the transfer sheet and rub down the letters. They will appear to float on the line, which can be erased without damaging the letters.

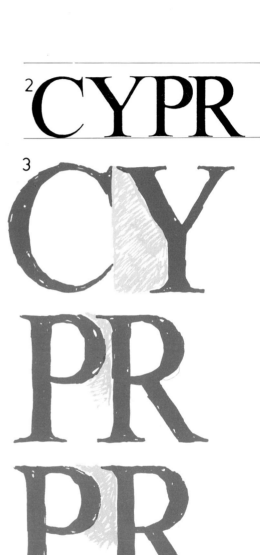

Talking to printers

There are many makes of typewriter and most can be used to produce clean copy for reproduction. If you are submitting the manuscript to a typesetter, there are ways to achieve clean copy which help in indicating your intentions.

Typewriter letterforms
There are two types of typewriter. Standard models and executive models. Each has a different number of characters per line.

A ABCDEFGHIJKLMNOPQRSTUVWXYZabcdefghijklmnopqrstuvwxyz1234567890*

B ABCDEFGHIJKLMNOPQRSTUVWXYZabcdefghijklmnopqrstuvwxyz1234567890*/@£$&¾()

C ABCDEFGHIJKLMNOPQRSTUVWXYZabcdefghijklmnopqrstuvwxyz1234567890*/@£$&¾()

A Standard pica
The copy produced has ten characters to an inch, with a normal line spacing of six lines to an inch.

B Standard elite
These produce twelve characters to an inch and, therefore, the type is smaller. They also produce six lines of normal spacing to an inch.

C Executive models
These machines often have interchangeable typefaces (golfball head) which produce varying sizes and styles.

Using typewriter text as artwork
Begin by cleaning the keys to ensure precise letter shapes. Type your text on clean white paper with a backing sheet in the typewriter. When assembling the text, replace paragraphs or lines with newly-typed copy. Do not replace individual words.

Adding variety
Text that is photocopied and included in the design can have interesting variations.
A Two typewriters with different typefaces.
B Enlarged text obtained on a stat machine and included.
C Dry transfer lettering or hand-drawn items.

A Using typewriter text as artwork

Type your text on clean white paper, with a backing sheet in the typewriter. Text that is photocopied and included in the design can have interesting variations.

A Two typewriters with different typefaces.
B Enlarged text obtained on a stat machine and included.
C Dry transfer lettering, or hand-drawn items.

B can have interesting variations
A Two typewriters with differen
B Enlarged text obtained on a s

C C DRY TRANSFER LETTERING,

or hand~drawn items

Preparing copy for press

Keep the manuscript clean and free of corrections. Calculate the number of characters per line of your intended text in its type size and type your manuscript to this width. Where possible, type the text in a style you wish it to appear in when typeset. Type each line with a one-line space between so that you have space for comments.

```
....1....1....1....1....1....3....1....4

There are many makes of typewriter and

most can be used to produce clean copy

for reproduction. If you are submitting

the manuscript to a typesetter, there

are ways to achieve clean copy which

help in indicating your intentions.

....1....1....1....1....1....3

Preparing copy for press

Keep the manuscript clean and
```

Emphasis

When using typewriter text in your final design, you have a limited number of methods of emphasis. Key words can be underlined (**a**), but this often creates irregularities if the descenders of the words touch the underlining; capitalizing the words (**b**); positioning the words outside the main body of the text (**c**) or leaving a line gap between each paragraph (**d**) and applying the other three techniques.

```
When using typewriter text in your final
design, you have a limited number of methods
of emphasis.
```
a ```
 Key words can be underlined, but this often
 creates irregularities if the descenders of
 the words touch the underlining.
```
**b** ```
    CAPITALISING THE WORDS, or placing words
```
c ```
 outside the main body of text.

 Leaving a line gap between paragraphs, or
 applying the three other techniques.
```
**d** ```
    PLEASE LEAVE A LINE FREE between paragraphs and
    type all in capitals with underlining, so
    you have no descenders.
```

Decorative elements

In addition to decoration by drawing or sticking on elements, you can use typewriter characters in a repetitive way to achieve borders or interval decorations.

```
XXXXXXXXXXXXXXXXXX      66666666666666666666
XOXOXOXOXOXOXOXOXO      SOSOSOSOSOSOSOSOSOSO
xixixixixixixixixi      +++++++++++++++++++++
mmmmmmmmmmmmmmmmmm      @@@@@@@@@@@@@@@@@@@@
momomomomomomomomo      :::::::::::::::::::::
mvmvmvmvmvmvmvmvmv      *:*:*:*:*:*:*:*:*:*:
AWAWAWAWAWAWAWAWAW      &&&&&&&&&&&&&&&&&&&&&
```

talking to printers

Having your designs printed by another person requires you to understand their production problems. Your first task is to evaluate the aspects of your design and your intentions for the printed results; then to discuss with printers their facilities and recommendations; then to obtain samples of earlier work printed in a manner similar to your intentions. Always think through the design to its final results as, unlike producing your own prints, time spent in exploring possibilities increases the costs and causes delay in production. Remember, printers are in business to make money. Their experience is an asset you can benefit from, but they can benefit from your inexperience and incompetence. Talking through every problem is cheaper than arguing about additional costs after completion of printing.

COMMERCIAL PRINTING CHOICES

Although most commercial printing presses were developed to produce particular types of prints, each can be used for a variety of needs.

Letterpress; used for designs with predominantly large quantities of text, which is set in metal or wood letters. Including photographs or drawings requires you to have the printer obtain a conversion of the image into halftone blocks.
Lithography; most suitable for large drawings or photographs as it can reproduce a wide range of tones. Small format jobs can be mounted up in multiples, printed, and then cut up.
Gravure; the cost of preparing plates makes this process only suitable for large editions in colour.
Screen printing; very successful at large printing areas such as posters. Very often the only method of printing on surfaces other than paper, such as fabric or plastic. Unsuitable for small images with tones or with small size text.

	LETTERPRESS	LITHOGRAPHY	GRAVURE	SCREEN PRINTING
BUSINESS CARDS	●	●		
STATIONERY	●	●		
GIFT CARDS	●	●		
TICKETS	●			●
PAMPHLETS	●	●		●
BOOKLETS AND BROCHURES	●	●	●	
MAGAZINES	●	●	●	
BOOKS	●	●	●	
POSTERS	●	●		●

WHERE TO PRINT

Do-it-yourself at home; requires space, the investment in tools, experience with the medium, but inexpensive. You learn by trial and error and get a sense of achievement.
Do-it-yourself in a studio; need to have access to facilities. Good tuition at hand, wider choice of techniques, and you can learn from activities of others. Only investment is paper and time, if studio has tools and presses.

Do-it-yourself in the office; inexpensive, quick to produce copies. Limited by only being able to produce black line images, often with poor quality results.
Commission a commercial printer; it costs money and you need to understand how to prepare artwork. Some printers are good, some bad. Requires you to think through all the aspects of your work.

WHAT YOU NEED TO CONSIDER

There are six main factors influencing your choice of medium to print your design.

1 The quantity of prints you require.
2 The quality of the prints.
3 The use of the prints.
4 The facilities available.

5 The complexity of the work.
6 The cost you wish to incur.

1 The quantity This is the most difficult aspect to estimate as overprinting results in excess prints which are wasted. Underprinting means not enough prints for your needs. Basically, printing more costs less as the unit price is reduced with the increased quantity.
2 The quality Are the prints ephemeral and of no value after being used, or do they represent a style or way of saying something which requires you to spend time and care on the objects?
3 The use This directly affects the size. Can it fit into envelopes? Can it be folded and bound into booklet form? How is it used? Need the text be small or big for easy reading?
4 The facilities available Can printers in your location do the sort of job require? Can you print the design at home? How often will you require new designs?

5 The complexity of the work There are three stages of complexity: your artwork may be too complex to assemble; the printer may have complex printing problems, like registering colour or cutting out elements; or the final printed job may be complex to assemble into booklet of final form.
6 The cost All the other facts control the price. When approaching a printer, try to resolve all the areas of cost and try to resolve your design into manageable parts. When reviewing your work, consider whether each unique element – unusual size, complex colour work, etc. – is worth the investment to achieve your ideas, or whether the same effect could be achieved by cheaper means.

talking to printers

When talking to printers, remember one simple rule: 'Get it in writing.' What you say, and what the printer understands, may be widely different and can seriously affect the price. Each job should have a written quotation from the printer as this forces you to examine all the aspects of your design and intentions. Additional costs usually occur for two reasons: either the original brief was different from the materials supplied to the printer, or changes made during the production. When you have agreed to work with a printer, insist on a set of proofs before the final version is printed.

BASIC PRINTING TERMS

Artwork; drawings, assembled typesetting or other text, normally positioned as the final copy on thin card.
Bleed; the parts of an image which are trimmed off after printing.
Camera-ready artwork; assembled text and images prepared for printing.
Collating; arranging the printed sheets in an order for binding.
Colour separation; converting coloured artwork or transparencies to the four-colour printing method.
Crop marks; indications on the artwork where the printed sheet is trimmed.
Dummy; a pre-production sketch or mock-up to indicate how the final design will appear.
Finishing; the stage after the sheets are printed, usually binding.
Halftone; photographs or drawings converted into reproduction form by being screened by a process camera.
Imposition; the arrangement of the pages during printing so that when cut up they form a consecutive sequence.
Landscape format; horizontal format, width greater than height.
Make-ready; work preparing the machines before printing.
Mechanical; artwork, photographs, drawings and text, assembled in position.
Overrun; copies printed in addition to the agreed quantities.

Paste-up; the same as mechanicals.
Plate; the surface from which the design is printed.
Portrait format; vertical format, width less than height.
Print and turn; a method where both sides are printed on one sheet, which then is turned and reprinted.
Proof; a preliminary printing to test the intended results.
Reverse out; negative version of elements of the design.
Run; total number of copies printed.
Show through; the printed impression appearing on the reverse side of the paper.
S/S; same size as the artwork.
Trimming; cutting the edges of the sheet to make them all the same size.
Unit price; the total cost divided by the quantity printed to establish the price of one item.

Print quotations

Printers' quotations are a response to your enquiries and should be checked to see they cover all the intended features of your job.

Size; this is the final trimmed size of the design.

Extent; this is the number of pages, very often this excludes covers.

Inks; this indicates whether the design is printed in one, two or four colours.

Paper; written specifications are hard to understand. Ask to see a paper sample.

Finish; this is the method of binding.

Origination; this indicates the form in which you will deliver the artwork. To

change this in any way will affect the price.

Proofs; the provision of preprinted samples to show the intended results before printing the total edition.

Delivery; the destination of the printed job.

Time; this is the time taken to print and deliver from the date of your submission of artwork. If your work has to coincide with an event, it is important to submit materials in time for the printer to complete the job.

Price; this price usually holds for three months after the date of the quotation.

Run-on price; this is for additional copies ordered before you print the total edition and is not a price for later copies.

Terms; the period you have before you pay the invoice.

Directors P A Lintern/J W Read/J M Clout/M J Davis R F Harris

The Yale Press Limited
PRINTERS · GRAPHIC DESIGNERS

Delga House, Carmichael Road, Norwood, London SE25 5LY
Telephone: 01-656 9655 (8 lines)

ESTIMATE 35184 FH Date 6th November 1986

Diagram Visual Information Ltd.,
195 Kentish Town Road,
London. NW5 8SY

For the attention of Mr. Bart Ullstein.

Dear Sir,

 We thank you for your recent enquiry and have pleasure in quoting you as follows:-

 MEMBERSHIP LISTING.

SIZE	A4.
EXTENT	16 pages.
INKS	One colour.
PAPER	115gsm Tinted Cartridge.
FINISHING	Stitch 2 wires and trim to one third A4 or two thirds A4.
ORIGINATION	You to supply line artwork.
PROOFS	5 sets
DELIVERY	London.
TIME	3 weeks after acceptance of artwork.
PRICE	7,000 Copies £1700.00
	1,000 Run on £ 190.00
TERMS	Net 30 days.

Yours faithfully,
The Yale Press Limited,

JOHN READ
Director.

This estimate is given subject to the Standard Conditions of Contract issued by the British Printing Industries Federation and printed overleaf which conditions shall be deemed to be embodied in any contract based on or arising out of this estimate except as may be otherwise indicated herein or subsequently agreed in writing

Reg No. 1142718 Reg Office: Delga House, Carmichael Road, Norwood, London SE25 5LY

Talking to typesetters

Typeset copy on your design gives it a professional look. It almost always involves you in preparing artwork from the printed text supplied by a typesetter. As typesetting is a mechanical process, you must indicate on your manuscript all your intentions of how the text should be set. If in doubt, ask to see some specimen setting in the size and style you intend. Consider carefully the final printing process, as some typefaces are not suitable for reduction or printing techniques. When submitting manuscript for setting, always keep a copy of your instructions so you can answer any queries by telephone. Wherever possible, type your manuscript in the way you intend it to appear – capitals typed in capitals, text spaced as intended. This reduces confusion and makes your instructions easier to follow.

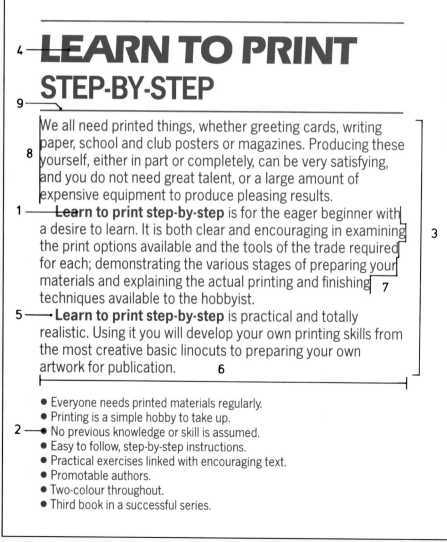

1 Bold
2 Bullet
3 Column
4 Display type
5 Indent
6 Measure
7 Ragged
8 Ranged
9 Rules

LEARN TO PRINT
STEP-BY-STEP

We all need printed things, whether greeting cards, writing paper, school and club posters or magazines. Producing these yourself, either in part or completely, can be very satisfying, and you do not need great talent, or a large amount of expensive equipment to produce pleasing results.

Learn to print step-by-step is for the eager beginner with a desire to learn. It is both clear and encouraging in examining the print options available and the tools of the trade required for each; demonstrating the various stages of preparing your materials and explaining the actual printing and finishing techniques available to the hobbyist.

Learn to print step-by-step is practical and totally realistic. Using it you will develop your own printing skills from the most creative basic linocuts to preparing your own artwork for publication.

- Everyone needs printed materials regularly.
- Printing is a simple hobby to take up.
- No previous knowledge or skill is assumed.
- Easy to follow, step-by-step instructions.
- Practical exercises linked with encouraging text.
- Promotable authors.
- Two-colour throughout.
- Third book in a successful series.

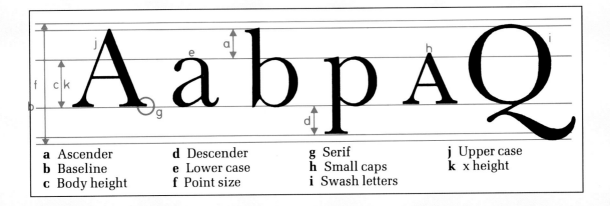

a Ascender	**d** Descender	**g** Serif	**j** Upper case
b Baseline	**e** Lower case	**h** Small caps	**k** x height
c Body height	**f** Point size	**i** Swash letters	

Typesetting terms

Ascender (**a**); part of the letter which is above the x height.

Baseline (**b**); the line on which the type sits.

Body copy; the main text.

Body height (**c**); the same as x height.

Bold (**1**); type which is in a heavier weight than the surrounding text.

Bullet (**2**); a printer's dot used to distinguish sentences or paragraphs.

Casting off; calculating the area the text will occupy when set in a particular size and typeface.

Centred; text which is positioned in the centre of a column or page.

Character; a letter or the choice of typeface and style of lettering.

Column (**3**); a block of text set to a measure.

Composition; the process of setting the text.

Copy; the manuscript submitted for setting.

Descender (**d**); part of the letter which is lower than the x height.

Display type (**4**) or display face; special typefaces which are usually decorative.

Em; a unit of measurement.

En; half an em.

Flush; beginning each line directly under the preceding line.

Galley; a column of typeset text, usually offered for corrections known as proof reading.

Indent (**5**); beginning a line of a block of copy further in from the edge.

Justification; setting the text so that both sides line up forming straight vertical edges.

Leading; the spacing between lines of text.

Letterspacing; the spacing between letters.

Linespacing; the spacing between lines of text.

Lower case (**e**); the small letters of the alphabet as opposed to capitals.

Mark up; the manuscript with indications of typesetting instructions.

Measure (**6**); the width of a column of text.

Pica; a unit of measurement.

Point size (**f**); the type size calculated in points.

Printers' flowers; decorative devices inserted by printers.

Proof; typeset copy submitted for examination, referred to as proof reading.

Ragged (**7**); uneven edges to the setting of a column of text.

Ranged (**8**); even edges to the setting, can be left or right.

Rules (**9**); lines, sometimes decorative, set or drawn.

Serif (**g**); the traditional ends to letterforms.

Small caps (**h**); capital letters which are the same height as the lower case – x height.

Swash letters (**i**); specialised letters with decorative elements.

Unjustified; copy set ragged, either left or right.

Upper case (**j**); the capital letters.

Weight; the thickness or heaviness of a particular typeface.

Widow; a line of copy with only one word at the end of a paragraph.

x height (**k**); the body height of the letters.

talking to typesetters

You have a number of considerations in selecting a typeface: the design of the letterforms; its typeface; the form of alphabet – whether it is capitals or lower case; the weight of the letters – whether it is bold, regular or light; the size of the letters; and the space between each line of copy, the leading. Typesetters in England and America measure copy sizes in units called points. The type is usually available in sizes ranging from 6pt (very small) to 72pt (very large). When specifying the type size, use the typesetter's catalogue as a guide as each typesetter varies his indications. The width of the lines of text is measured in units of multiples of 12pts, known as ems or picas. European typesetters use a similar method but calculate on units of a different size called ciceros.

©DIAGRAM

Type scales
A A basic type scale of ems (12pt units).
B Inches for comparison.
C Ciceros.
D Centimetres for comparison.

Typefaces
There are hundreds of different typefaces, but normally you are restricted to those available to the typesetter. The same copy, set in different typefaces, occupies different lengths as each typeface has differing features of letterform which affect the overall length. The examples (*right*) are all set in the same size, but in differing typefaces.

abcdefghijklmnopqrstuvwxyzæœøß.,!?
ABCDEFGHIJKLMNOPQRSTUVWXYZ&ÆŒØ

abcdefghijklmnopqrstuvwxyzæœøß.,!?
ABCDEFGHIJKLMNOPQRSTUVWXYZ&ÆŒØ

abcdefghijklmnopqrstuvwxyzæœøß.,!?
ABCDEFGHIJKLMNOPQRSTUVWXYZ&ÆŒØ

abcdefghijklmnopqrstuvwxyzœœøß.,!?
ABCDEFGHIJKLMNOPQRSTUVWXYZ&ÆŒ

abcdefghijklmnopqrstuvwxyzæœøß.,!?
ABCDEFGHIJKLMNOPQRSTUVWXYZ&ÆŒØ 12

abcdefghijklmnopqrstuvwxyzæœøß.,!?
ABCDEFGHIJKLMNOPQRSTUVWXYZ&ÆŒØ 123

Type sizes

The type size is not the height of the capital letters but the total size of the letters which includes the tiny space above and below. The examples (*right*) are actual size of a typeface from 6pt to 36pt.

6 abcdefghij ABCDEFGHIJ
7 abcdefghij ABCDEFGHIJ
8 abcdefghij ABCDEFGHIJ
9 abcdefghij ABCDEFGHIJ
10 abcdefghij ABCDEFGHIJ
11 abcdefghij ABCDEFGHIJ
12 abcdefghij ABCDEFGHIJ
14 abcdefghij ABCDEFGHIJ
16 abcdefghij ABCDEFGHIJ
18 abcdefghij ABCDEFGHIJ
20 abcdefghij ABCDEFGHIJ

24pt abAB 30pt abAB 36pt abAB

Type style

Many typefaces are available in a range of styles. The example (*right*) is Europa Grotesk.

1 Lower case.
2 Upper case (capitals).
3 Small capitals.
4 Italic.
5 Condensed.
6 Normal (regular).
7 Extended.

1 abcdefghijklmnopqrstuvwxyzæœøß.,!?
2 ABCDEFGHIJKLMNOPQRSTUVWXYZ&ÆŒØ
3 ABCDEFGHIJKLMNOPQRSTUVWXYZ&ÆŒØ
4 *abcdefghijklmnopABCDEFGHIJKLMNOP*
5 abcdefghijklmnopqrsABCDEFGHIJKLMNOPQRST
6 abcdefghijklmnopABCDEFGHIJKLMNOPQR
7 abcdefghijklmnABCDEFGHIJKLMNO

Type weight

Each typeface has a variety of weights, and each weight affects the line length and emphasis.
The alphabets (*right*) are all the same typeface and size.

1 Light.
2 Regular.
3 Bold.
4 Ultra bold.

1 abcdefghijklmnopqrstuvwxyzæœøß.,!?
ABCDEFGHIJKLMNOPQRSTUVWXYZ&ÆŒØ 1234567890

2 abcdefghijklmnopqrstuvwxyzæœøß.,!?
ABCDEFGHIJKLMNOPQRSTUVWXYZ&ÆŒØ 1234567890

3 **abcdefghijklmnopqrstuvwxyzæœøß.,!?**
ABCDEFGHIJKLMNOPQRSTUVWXYZ&ÆŒØ 123456

4 **abcdefghijklmnopqrstuvwxyzæœøß.,!?**
ABCDEFGHIJKLMNOPQRSTUVWXYZ&ÆŒØ 123

Leading

The space between lines affects the legibility and produces different tonal qualities of the block of copy. The example (*right*) is of this text set:

1 solid (10pt on 10pt).
2 one point leaded (10pt on 11pt).
3 two point leaded (10pt on 12pt).
4 four point leaded (10pt on 14pt).

Leading 1
The space betw affects the legi produces diffe qualities of the copy. The exar of this text set:
1 solid (10pt c
2 one point le 11pt).
3 two point le 12pt).
4 four point le

Leading 2
The space betw affects the legi produces diffe qualities of the copy. The exar of this text set:
1 solid (10pt c
2 one point le 11pt).
3 two point le 12pt).

Leading 3
The space betw affects the legi produces diffe qualities of the copy. The exar of this text set:
1 solid (10pt c
2 one point le 11pt).
3 two point le

Leading 4
The space betw affects the legi produces diffe qualities of the copy. The exar of this text set:
1 solid (10pt c
2 one point le 11pt).

169

talking to typesetters

Marking up manuscript and checking the resulting text requires you to pay very close attention to what you require of the typesetter. Keep a record of your submitted manuscript, and of your corrections to the proofs. Mistakes made in your manuscript submission will be charged to you separately as author's corrections.

Copy calculations
When you require to know the extent of the manuscript, to test it for fit when converted to typesetting, there is a simple method of calculating the amount of text in your existing manuscript.
1 Count the number of words in ten lines.
2 Divide the number by ten to obtain an average per line.
3 Count the number of lines of copy on the page, or in the manuscript.
4 Multiply the average per line by the number of lines to obtain the total number of words.

Proof corrections
When correcting the typesetter's text, keep the marks clear, and make a second copy for reference.
1 Bold.
2 Lower case.
3 Upper case.
4 Insert letters.
5 Increase space.
6 Move to left.
7 Move to right.
8 Transpose text.
9 Delete copy.
10 Damaged or dirty copy.
11 Reverse (type upside down).
12 Close up.
13 Delete and close up.
14 Insert space.
15 Copy not straight.

Image printing and word printing are closely linked activities. The methods available for duplication of images are also used for words. Fine prints frequently included words as a decorative element, and texts included images for the same reason. Posters, covers for publications, images alongside texts in books, and every other form of graphic communication, have words and pictures combined. Letterforms may be hand-drawn in the style of the artwork or included by mechanical means such as photography or typography. Whatever method is employed, it is essential that you view the total effect of the elements and avoid considering the art as an independent feature of the print.

1 : 60 WORDS
2 : 60 ÷ 10 = 6
3 : 17 LINES
4 : 17 × 6 = 102 WORDS

Learn to print
Methods of reproduction
There are four major methods of duplicating IMages by printing: the relief process, where raissed surfaces are inked and pressed onto paper;the process intaglio, where incised (lowered surfaces) are inked and pressed onto paper; the stencil process, where holes allow ink to pass through a surface onto paper. each method offers unique qualies and different results.Before transforming your drawing to a method of reproduction, firstconsider the available available opportunities that each met hod offers.

170

Marking up copy
When marking up text, keep all indications very clear.
1 Set in capitals.
2 Set in italic.
3 Set in bold.
4 Indent copy.

5 Spell out.
6 Set in lower case.
7 Set in roman.
8 Insert full point.
9 Retain original copy.
10 Continue or run on text.
11 Leave space.

a The size and leading.
b The typeface and weight.
c The column width.
d How the column edges should be aligned.
e Spacing between words and letters.

SET IN 11/12pt *(a)* MELIOR REGULAR *(b)*, u/lc
TO 17 PICAS MAXIMUM MEASURE. *(c)*
RANGE LEFT, RAGGED RIGHT. *(d)*
REGULAR WORD/LETTER SPACING *(e)*

Learn to print *(1)*

Methods of reproduction *(3)*

There are four major methods of duplicating images by printing: the relief *(2)* process, where raised surfaces are inked and pressed onto paper; the intaglio *(2)* process, where incised (lowered surfaces) are inked and pressed onto paper; the surface *(e)* process, where FLAT areas are inked and pressed onto paper; the stencil *(2)* process, where holes allow ink to pass through a surface onto paper. *(10)*

l.c. *(6)*

Each method offers unique qualities & different results *(8)* Before transforming your drawing to a reproduction method, first consider the available opportunities that each method offers.

SPELL OUT *(5)*
ROMAN *(7)*

(11) # ▷ The relief process

STET

(4) The most common materials from which you can cut away areas, which will appear white when the raised inked surfaces will print black are:

10/11pt *(a)*
TO 11 PICAS *(c)*

© DIAGRAM

171

talking to typesetters

Text is normally produced independently of the design and then stuck in position on the master artwork. The considerations are mainly the availability of methods of creating the text, and the suitability for the intended printing process. Texts which are transferred by hand must be simple in style. Texts which are photographed and created mechanically on the plate, block or screen, can be very varied.

1 **BABIES AND TODDLERS GROUP MUMS WELCOME**

2 **BABIES** AND **TODDLERS** GROUP MUMS WELCOME

Choice (*above*)
Considerations are:
1 Size; differing sizes in one design.
2 Weight; some heavier.
3 Character; different styles.
4 Colour; differing colours.
5 Positions; some in different positions.
The poster (*left*, reduced) used the first four techniques to achieve variety.

Additional elements
Printers often have borders and decorations available, which you could use to enhance your designs.

3 BABIES
AND
TODDLERS
GROUP
MUMS
WELCOME

4 BABIES
AND
TODDLERS
GROUP
MUMS
WELCOME

5 BABIES
AND
TODDLERS
GROUP
MUMS
WELCOME

1 Text is normal
produced inde
of the design
then stuck in
on the maste
The conside...

2 Text is normally prod
independently of the
and then stuck in pos
the master artwork. T
considerations are ma
the availability of m
creating the text, an
suitability for the i
printing process. Tex
which are transferred

3 Text is normally produ
independently of the
design and then stuck ii
position on the master
artwork. The
considerations are mair
the availability of
methods of creating the
text, and the suitability
the intended printing

a

A Text is normally produced
independently of the design
and then stuck in position on
the master artwork. The
considerations are mainly
the availability of methods of
creating the text, and the
suitability for the intended
printing process. Texts
which are transferred by

B Text is normally produced
independently of the design
and then stuck in position on
the master artwork. The con-
siderations are mainly the
availability of methods of
creating the text, and the
suitability for the intended
printing process. Texts which
are transferred by hand and
implemented by hand, must
be simple in style. Texts

C Text is normally produced
independently of the design
and then stuck in position on
the master artwork. The
considerations are mainly
the availability of methods of
creating the text, and the
suitability for the intended
printing process. Texts
which are transferred by
hand and implemented by
hand, must be simple in

D Text is normally produced
independently of the design
and then stuck in position on
the master artwork. The
considerations are mainly
the availability of methods of
creating the text, and the
suitability for the intended
printing process. Texts
which are transferred by
hand and implemented by
hand, must be simple in

Method
Three basic methods of
producing text:
1 Handwritten
2 Typewritten
3 Typeset

Position
The text is usually produced
to a consistent width – the
measure (**a**). Each line can be
ranged left (**A**) so it starts on
the left hand side; justified
(**B**) so the left and right hand
sides begin and end under
the preceding line; ranged
right (**C**) so it begins
irregularly (ragged) but
always aligns at the right
hand side; or each line
centred (**D**) under the
preceding line.

Format and form

Printed surfaces can be folded, cut and reassembled, or combined to create a wide variety of formats. The flat printed surface, when folded into more than four sides, can be bound in covers to form a book. Each side of a sheet now created is called a page. When designing the elements on the total sheet, each page surface must be considered in its relationship to the others.

Size
When selecting the size of your printed object, three factors influence your choice.
1 The size of the printing press, as this controls the maximum area onto which you print.
2 The size of the paper available. Manufactured papers vary in size as a result of type or nationality.
3 The use of the object. Celebration cards should fit into regular size envelopes. Brochures and reports should be able to be stored in normal filing systems, and publications should not exceed the average bookshelf height.

Folding
Folding a sheet to create individual faces (pages) produces an object in which the interplay of surfaces enables you to consider both sides of the sheet as part of the same object.

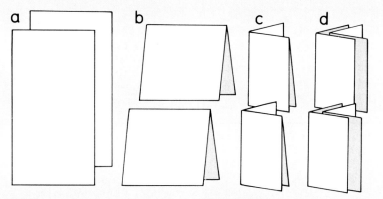

Units
Two sheets of similar size (**a**) are folded in halves (**b**), and then folded again along an axis at 90° to the first fold (**c**). The resulting two units are then trimmed along the top edge (**d**) to form two groups each of two pieces. These units are called signatures and are the basic unit of all bound publications.

Signatures
Because these are the result of folding and cutting, they contain even numbers of pages, normally 8, 16, 32 or 64 pages. The first page is always no. 1, the second (on the inside left) is 2 and it follows that all even numbers will be on the left and all odd numbers on the right throughout the signature.

Binding
The choice of binding depends upon cost, availability and use. Without it the signature would fall apart or become out of sequence with use. There are several methods available.
A Mechanical; wire staples punched through all the pages, but only possible for one signature in the publication.

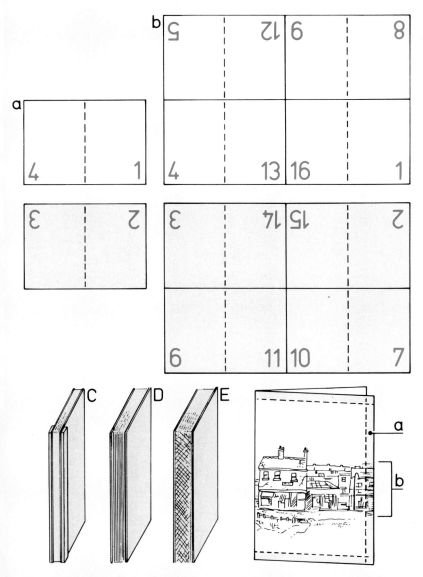

Imposition

The relationship of each page of a signature is known as the imposition. Each fold of the sheet doubles the number of already created pages. One fold creates four pages; two create eight pages; three create sixteen pages and four folds create thirty-two pages. Because the surfaces of the sheets are turned when folded, it is important to remember the positions in the original printing. Sheet (**a**) is for a one-fold signature, and sheet (**b**) for a three-fold one. Both show front (white) and back (grey) sides. Note the relationship of the pages to one another.

B Machine bound; using wire loops (**a**) or plastic spiral (**b**) which hold and combine all pages.
C Plastic grips which can be removed if required.
D Gluing; a technique used for commercial bindings such as trade paperbacks.
E Sewn; the traditional book method in which the stitching combines pages and signatures.

Trim
Folded sheets are cut along the exposed edges after they have been bound together to ensure that all pages have a common size. This cutting is called trimming the page (**a**) and usually removes about 5mm (⅛″). Illustrations which exceed the page and have a section removed are said to bleed (**b**) from the page. When trimming pages, take care to ensure that your cutting board is thick enough to protect the surface of the table on which you work. Use a metal edge to cut against. Never use a wooden rule, or make deep cuts, but cut along the edge lightly and frequently until all pages are cut.

175

format and form

When considering a sequence of pages, it is advisable to construct a grid of the pages. This is a linear structure in which the elements of each page relate to their positions and sizes on preceding pages. All the text can be a common width and all the pictures sized to similar dimensions. Grids should not be considered as a restriction, nor an absolute rigid formula, but as an aid to the possible location of items on each page.

Variety
A division of two facing pages into four units each offers you the opportunity of locating an illustration on the pages in eight different positions. By adding text in one further unit, you have over fifty possible combinations.

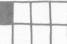
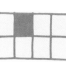
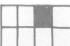
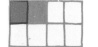

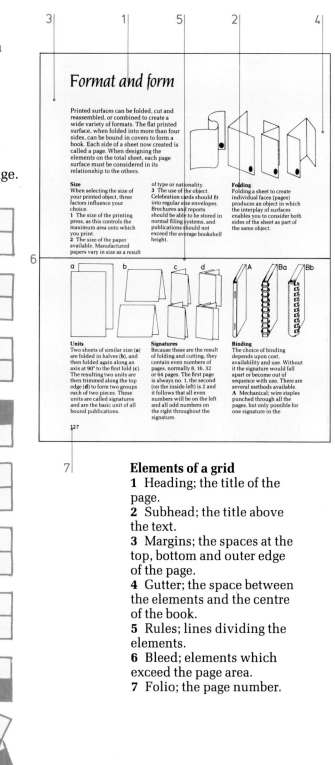

Elements of a grid
1 Heading; the title of the page.
2 Subhead; the title above the text.
3 Margins; the spaces at the top, bottom and outer edge of the page.
4 Gutter; the space between the elements and the centre of the book.
5 Rules; lines dividing the elements.
6 Bleed; elements which exceed the page area.
7 Folio; the page number.

This book's grid

The grid (*left*, reduced) was used to design the 192 pages of this book; the text and illustrations sized and positioned on coordinates of the grid. Six preceding pages have been printed here (reduced) with the grid superimposed so that you can see the way in which the elements interrelate.

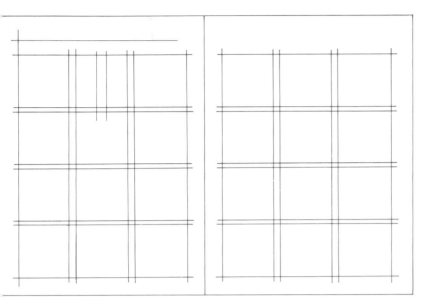

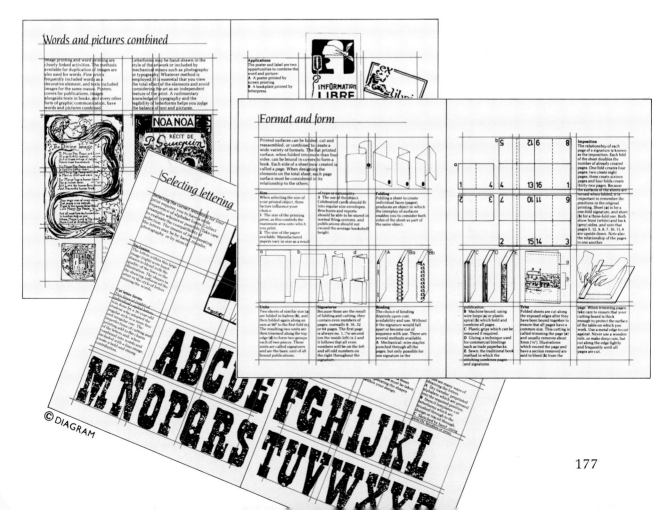

© DIAGRAM

Preparing artwork for press

Preparing the artwork for press involves assembling the text and line images on a flat surface, in the sizes and positions intended for printing. Care must always be taken to keep the work clean and accurate. Remember that the quality of artwork is the quality of a proof. Printers cannot improve on the materials submitted.

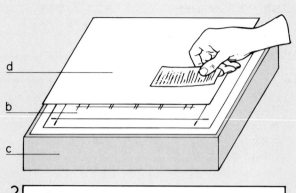

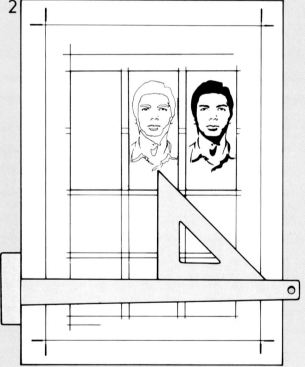

Assembling artwork
1 Begin with a basic design grid, drawn lightly in blue pencil on card (**a**), or use a master grid (**b**) placed over a light box (**c**) and work on an overlay card (**d**).
2 Stick down all line artwork and add rules.
3 Stick all the text and headings onto the card, using a set square to test for accuracy. Avoid corrections of single words (**e**) but try to replace complete lines (**f**). Check that the next section of copy is square with preceding lines (**g**). When trimming out, try to leave 5mm (³⁄₁₆″) around the text as the edges of the paper cause shadows which can appear on the printer's film. Indicate the areas occupied by photographs in a blue line (**h**).
4 Size up halftones, indicating the area required and the resulting dimensions.

Basic rules for preparing artwork for press

- Keep everything clean; dirt shows and will print.
- Keep everything square; printed results will expose inaccurate work.
- The results, when printed, will never be better than the artwork.
- Badly cut pieces when stuck down will reveal shadows when printed.
- Supply halftone images independently from line images.
- Work same size as printed results, or discuss with the printer possibilities of working larger for reproduction.
- Read every part of the final paste-up very carefully. What is assembled is what is printed; corrections later are expensive.
- Protect and store the artwork carefully.
- Never fold or roll artwork.

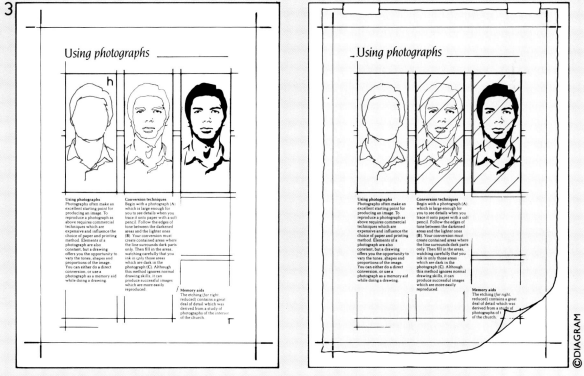

The reduction method of colou ~~is~~ is the simple process of cutting block, printing in a colour, ~~cutte~~ from the same block, then over and continuing in as many col~~o~~ f you wish. The method require~~s~~ think through your design bef~~o~~ starting, and printing from the~~]~~ as many proofs as you require ~~a~~ g cannot reprint the original ima the block has been cut the seco

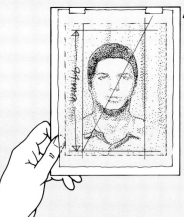

Adding colour

When the design has second colour elements, these are best indicated with an overlay, which protects the page during production. To achieve irregular second colour areas, it may be necessary to draw these in ink on an overlay, so that they can be photographed and used as a mask for colour.

179

preparing artwork for press

Using photographs in your design requires you to have experience of the printed results. The tonal range of photographs can vary in printing as a result of the method of reproduction, the screen conversion size and the paper onto which the image is printed. Photographs must always be supplied to the printer flat with no folds. Do not draw on photographs and, if working on overlays, use a soft pencil.

Cropping
Indicating the area of the picture is best done with a soft pencil on a tissue overlay. Make sure that one dimension, preferably the width, is clearly marked.

Conversion to print
To achieve the tonal range of a photograph, it is subjected to a mechanical screen which converts the range of tones into groups of tiny dots. These can be widely spaced (**a**) referred to as coarse screen; or very closely spaced and very small (**b**) referred to as fine screen.

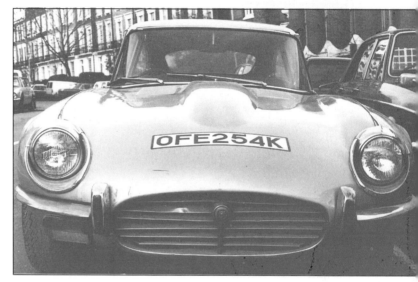

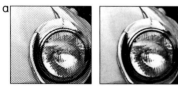

Line conversions
Photographs can be converted either by photocopying or by instructions to the printer. This technique enables you to incorporate the images into the surface of your paste-up without the additional costs of halftone inclusion.

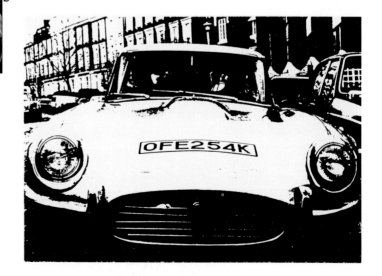

Sizing photographs

All sizes of a rectangle, with the same height to width ratio, have a common diagonal and this principle can be used to establish the new sizes given a width or height to which you wish to convert the photograph.

1 Cover your photograph with a paper overlay and draw a diagonal on it.
2 Project this to the new width, then measure the new height, and indicate this on the photograph. The same applies to the required width.

Sizing by ratio

To calculate the new size of a photograph without recourse to a diagonal, use a proportional slide rule (**a**). Rotate the centre disc to a point (**b**) where the present height corresponds with the intended height. The width of the original can now be read off against the enlarged new width of the image. For example, if the original height was 30 and the new dimension 3, then a width of 60 would be 6.

Photographic edges

The photograph need not be rectangular. You can instruct the printer to remove the area around the image (**a**) to obtain a 'cut out' photograph, or to set the photograph in another shape, a vignette (**b**).

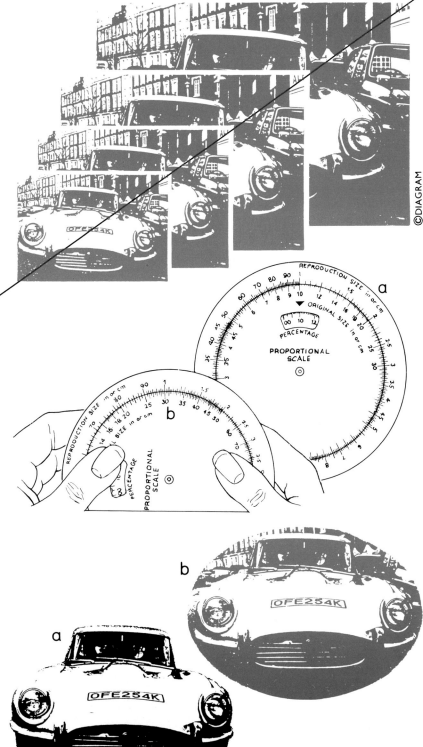

©DIAGRAM

preparing artwork for press

Before beginning the artwork, always consider the intended print technique and the most effective way to achieve your intentions. Gradations in pencil, brush, airbrush or chalks must be screen converted like a photograph. Line drawings without tone can be processed in the same way and at the same time as the text.

Three examples printed the same size as they were drawn to illustrate different methods of preparing artwork.

Line detail (*right*)
With care, the full range of tones on a photograph can be achieved by hand. This usually requires drawing skills and is very time-consuming to capture accurately the photographic detail.

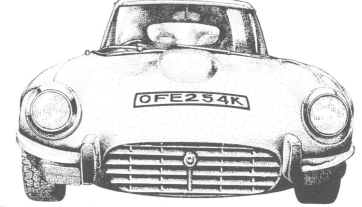

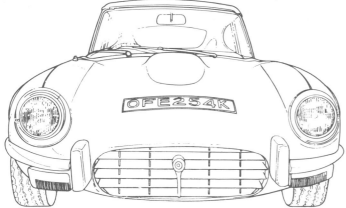

Outline drawing (*left*)
A style very suitable for most reproduction techniques. Care must be taken to create lines which are continuous and of equal strength, so that in production they do not break up or fill in.

Tonal drawing (*right*)
Working in pencil enables you to achieve a wider range of tones, but it also is more difficult to reproduce. This drawing is printed in the same manner as a photograph.

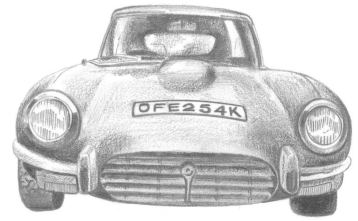

Reduction technique

Many artists draw the image considerably larger than the final printed version. This sharpens the detail in the printed version. The drawing (*far right*) is a reduction of a drawing; detail (*right*, actual size).

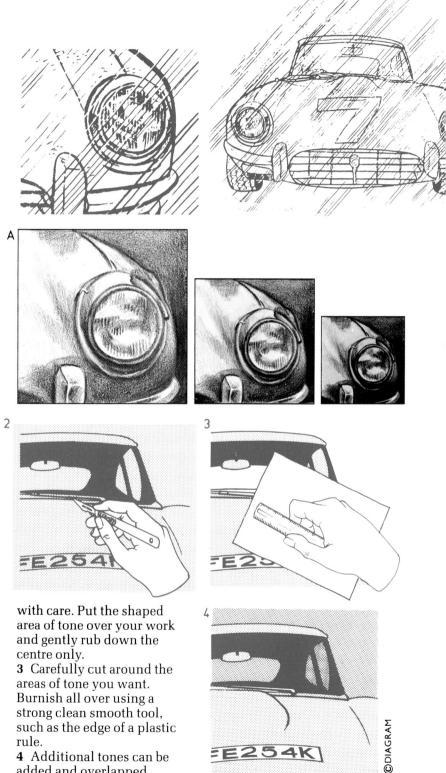

Tonal reductions

When changing the size of a drawing, care must be taken to adjust the tonal values of the original as a drawing darkens when it is reduced. The three examples (*right*) are different sizes of the same artwork; (**A**) is actual size.

A

Applying mechanical tones

1 First complete your drawing in line.
2 Lay over it part of the texture sheet with its backing between your work and the film tone. With a scalpel cut out roughly, but not wastefully, the area required. Remove the backing sheet and the unused parts of the tone with care. Put the shaped area of tone over your work and gently rub down the centre only.
3 Carefully cut around the areas of tone you want. Burnish all over using a strong clean smooth tool, such as the edge of a plastic rule.
4 Additional tones can be added and overlapped.

©DIAGRAM

183

Storing prints

Prints are created in an edition. That is in the total number of copies printed from the plate. Each print must be carefully stored and a record kept of the edition. When buying prints, it is better to buy for pleasure with a view to displaying it in your home or office. Buying for investment and storing seems somehow to defeat the intentions of the artist.

Storing
Prints must always be stored flat, never folded, either in a plan chest (**1**) or portfolio (**2**). When stored, they must be interleaved with tissue paper (**3**). When transported, they can be rolled and kept in tubes (**4**).

Proofing marks
Progressive states of the print should be numbered 1st, 2nd, 3rd state, and, if more than one copy is made of any state, then these should be numbered. The final artist's proofs should not exceed five, and should be marked A, B, C, D, E or I, II, III, IV, V, to distinguish them from the final edition. Each print of the edition should be marked with the number of the order in which it is taken and the total edition number. For example, 12/50 is the twelfth print of an edition of fifty. Each print must be signed by the artist.

Records
As prints are sold or given as gifts, it becomes necessary to keep a record of the information related to the edition. The best method is always to retain a copy and in a permanent notebook record the following information: dimensions of the plate; method of printing; quantity of the edition; exhibitions or prizes connected with the print; copies sold and to whom, and prices. After printing the edition, the plate must be defaced or destroyed to avoid later reprintings.

Sale of prints
Establishing the value of individual prints is difficult. Normally galleries selling prints purchase them from the artist at two-thirds of the sale price. If the gallery buys the total edition, it usually offers to purchase it for 50% of the sales value. Whenever considering selling prints, remember there are no real rules. Whatever appears fair to you is a fair deal. Never have regrets, learn from your mistakes.

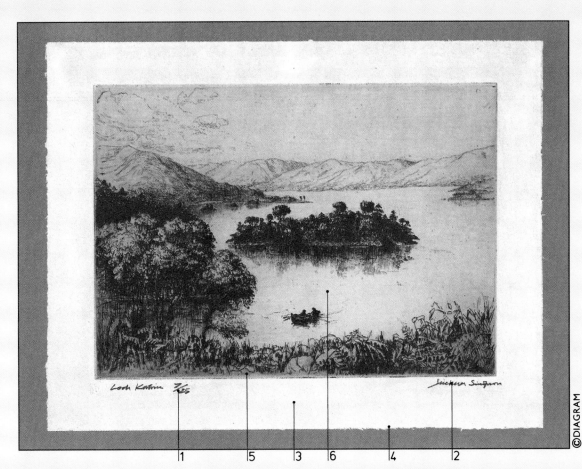

| | | | | | |
|1|5|3|6|4|2|

Print state

Each print should have certain features which identify it and also help you judge its condition.

1 Impression data and title of print, if it has one.
2 Author's signature.
3 Wide margins.
4 Torn paper edge (not cut or trimmed edges).
5 Indent caused by plate edge.
6 If newly editioned and purchased, all surfaces back and front, and margins should be in perfect condition.

Defects

Prints with defects should not be sold or purchased. Folding marks; prints must be stored flat.
Tear marks; if these enter the impression area the print is worthless.
Margin stains; usually due to dampness.
Prints must never|be trimmed to the edge of the image, or within the impression area. Some prints, however, are designed and printed to the edge of the paper.
Any substandard inking or printing reduces its value.

Value

The value of a print is judged by three factors: its rarity, its condition and the reputation of the artist. Never buy damaged prints or prints in poor condition. Always look for identification marks. Remember to examine the back of the print. Never be tempted to buy prints whose reproduction method is unclear as these are likely to be of dubious quality or origin.

©DIAGRAM

Mounting and framing prints

There are no rules as to the correct mount, frame or location of prints. Arrangements which please you are the correct ones. Certain framing techniques and styles have become traditionally accepted but these conventions are changing with the introduction of new materials and fixing techniques. Just like spectacles on a face, the character of a frame can greatly enhance or mar the effect of the print so consider your selection with care. When finally framed, re-evaluate the results against the surrounding conditions of the intended position.

Location

A print, when mounted and framed, makes an excellent wall feature. Colour prints brighten dark corners and can be used as a focal point in all parts of a house.

1 In hallways and staircases as these have no furniture.

2 Above a fireplace as a centre of attention.

3 Small prints arranged in a group.

4 Avoid locating prints near natural light as strong light can affect the pigmentation of inks and cause both the print and the paper to discolour with age.

5 Try to hang the prints in positions approximately in line with the average eye level, about 5 feet above the floor.

Cutting a window mount

1 Cut mounting card to size and select the area of the print to be shown.

2 Ensuring that the corners are square, outline the inside of the mounting frame.

3 Prick a hole through the mounting card in the corners with a pin.

4 Carefully cut out the inner edges of the mounting frame using a very sharp blade and a metal ruler. Attach the print to the back of the mounting card with double-sided tape or small spots of glue in the corners. Do not attempt bevelled edges until you have had a lot of practice.

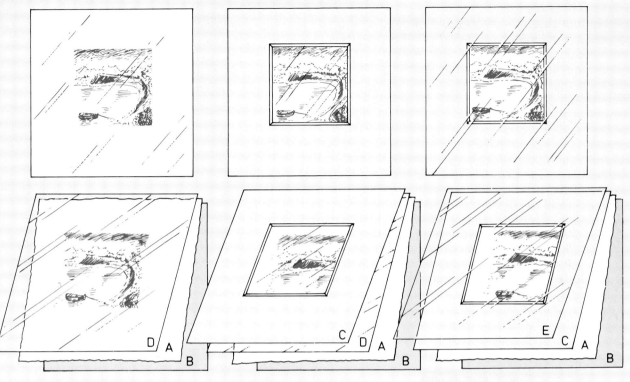

Direct mounting
Trim your print to a regular shape. For temporary mounting, lightly fix it to a backing card and cover with clear plastic, or glass if it is to be on display, If the print is stuck down firmly it will be impossible to remove without damaging it.

Window mounting
For temporary mounting, your print can be displayed in a frame made of card and protected with a clear sheet of acetate put under the mount. Skill and practice are required in cutting a clean hole in the mounting card.

Window mounting for permanent display
Use the same method for cutting a window mount; place your print onto backing card; place the mount on top of your print and cover with glass.

A Print
B Backing card
C Window mount
D Acetate
E Glass

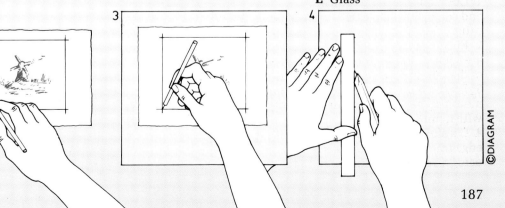

mounting and framing prints

Elements
There are three elements to consider when displaying a print.
1 There must be a margin visible round the print showing the number of the print and the edition.
2 The mount can be any colour and size, depending on your taste.
3 The frame: traditionally thin and dark, but more modern solutions in bright colours and shapes are now available in stores.

The frame
Too heavy a frame overpowers the print. This sort of frame should only be used for a small etching or wood engraving.

The shape of the mount
Normally a rectangle is best suited to a print but oval, circular or arched mounts can be attractive. However, cutting curved edges in the mount requires great skill and experience.

Positioning of print

A balanced effect is achieved by making the mount slightly deeper at the bottom than at the top. The sides should be kept to the same depth as the top. The mount should also not overpower the print but enhance it.

Lines around a mount

Many mounts have fine lines or rules close to the window which emphasize the edges of the print and the frame. These should only be attempted after much practice as they are difficult to draw.

The background

The colour, tone and area of the surrounding mount and frame will affect the print. Use colour papers to test out your ideas and explore what happens when you put the print on different backgrounds.

Index

Specialist suppliers

T. N. Lawrence & Son Ltd
2–4 Bleeding Heart Yard
Greville Street
London EC1N
Tel: 01 242 3534

M. J. Putnam
151 Lavendar Hill
London SW11
Tel: 01 228 9087/9603

Intaglio Printmaker
20 Newington Causeway
London SE1
Tel: 01 403 6585

E. T. Marler Ltd
Deer Park Road
London SW19
Tel: 01 540 8531

Sericol Group Ltd
24 Parsons Green Lane
London SW6
Tel: 01 736 3388

Howson Algraphy
Ring Road
Seacroft
Leeds LS14 1ND
Tel: 0532 737475

Atlantis Paper Technology Ltd
105 Wapping Lane
London E1
Tel: 01 481 3784; 488 4321

R. K. Burt & Co Ltd
Paper merchants
57 Union Street
London SE1
Tel: 01 407 6474